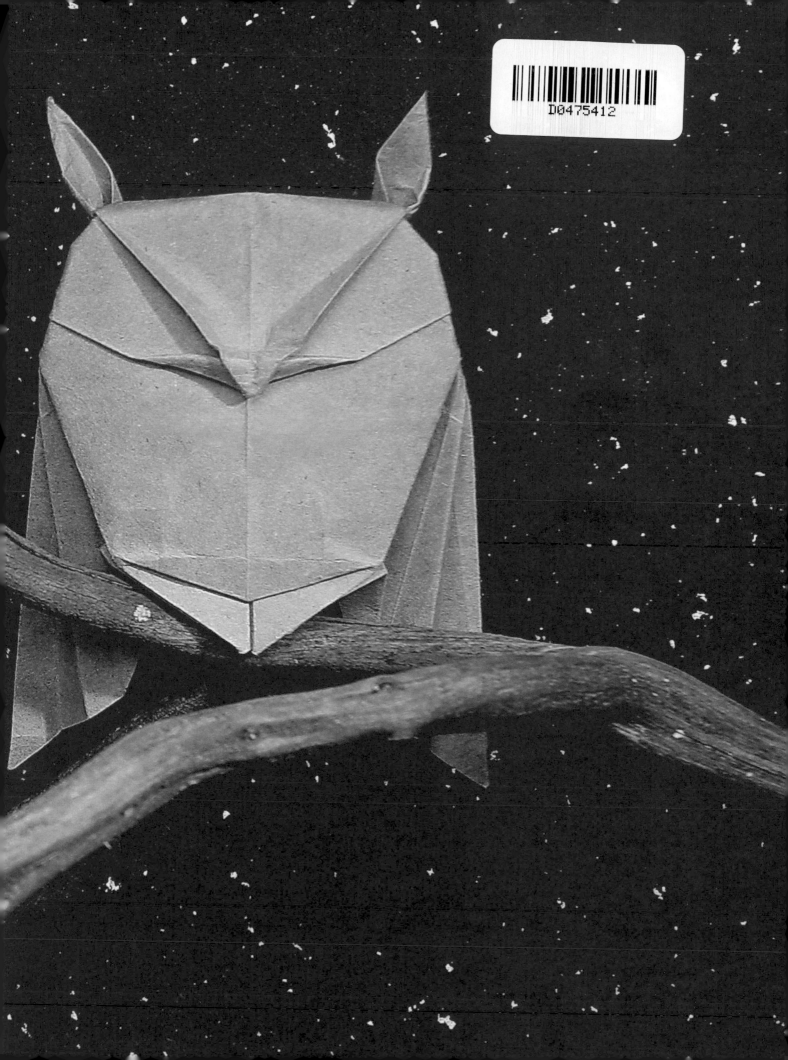

ORIGAMI ODYSSEY

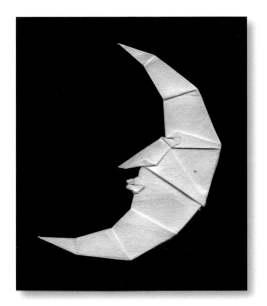

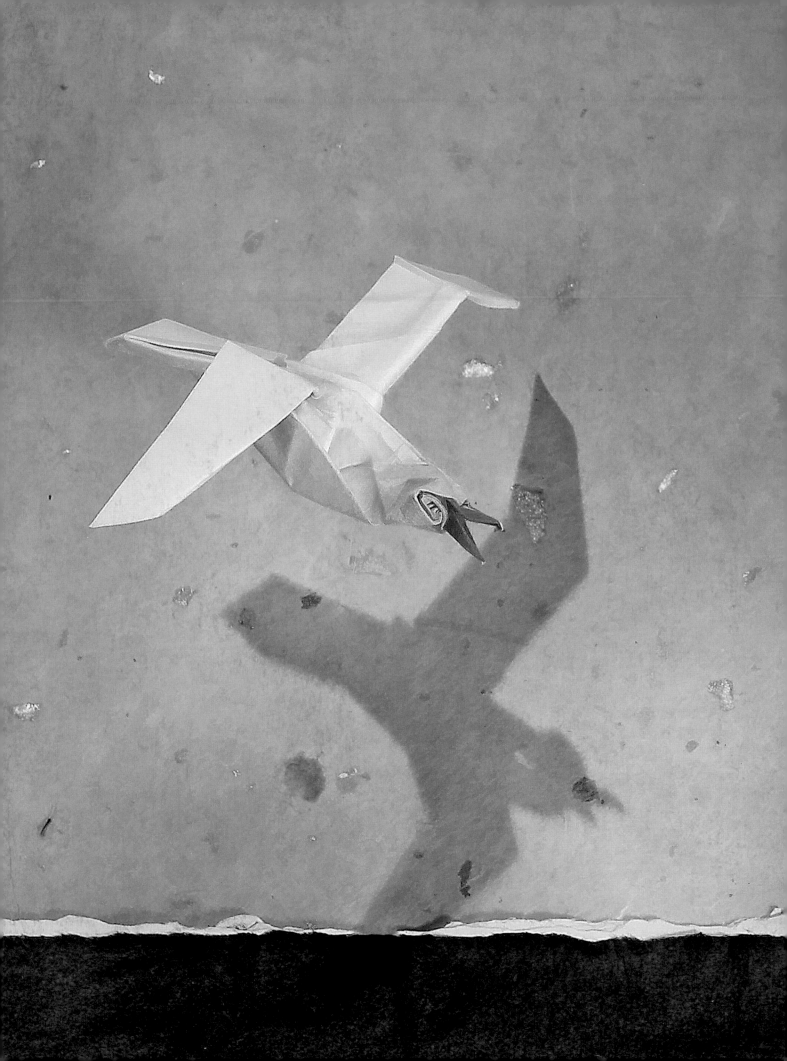

ORIGAMI ODYSSEY

A Journey to the Edge of Paperfolding

PETER ENGEL

with a foreword
by Nondita Correa-Mehrotra

TUTTLE Publishing

Tokyo | Rutland, Vermont | Singapore

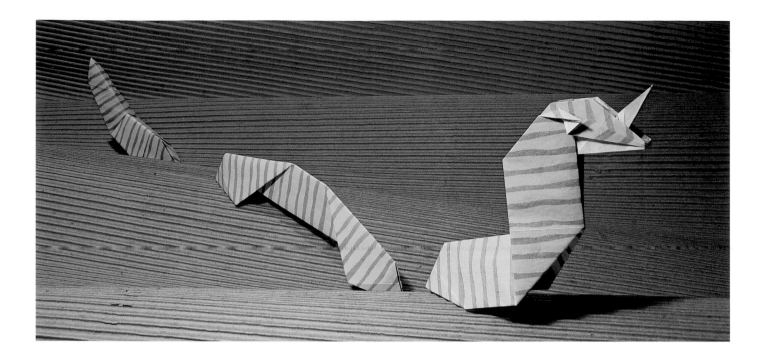

Distributed by:

North America, Latin America & Europe
Tuttle Publishing
364 Innovation Drive
North Clarendon, VT 05759-9436
Tel: (802) 773-8930
Fax: (802) 773-6993
info@tuttlepublishing.com
www.tuttlepublishing.com

Japan
Tuttle Publishing
Yaekari Building, 3rd Floor
5-4-12 Ōsaki
Shinagawa-ku
Tokyo 141 0032
Tel: (03) 5437-0171
Fax: (03) 5437-0755
sales@tuttle.co.jp
www.tuttle.co.jp

Asia Pacific
Berkeley Books Pte. Ltd.
130 Joo Seng Road
#06-01/03 Olivine Building
Singapore 368357
Tel: (65) 6280-1330
Fax: (65) 6280-6290
inquiries@periplus.com.sg
www.periplus.com

ISBN 978-0-8048-4119-1

Printed in Hong Kong
First edition
15 14 13 12 11 1102EP
10 9 8 7 6 5 4 3 2 1

Published by Tuttle Publishing, an imprint of Periplus Editions (HK) Ltd.

www.tuttlepublishing.com

Copyright © 2011 Peter Engel

M.C. Escher's "Reptiles" © 2010 the M.C. Escher Company-Holland. All rights reserved. www.mcescher.com, p.14

Froebel paperfolding: Photography © by Kiyoshi TOGASHI, p.17

Figures 127 and 128 from *On Growth and Form* by D'Arcy Thompson, abridged edition edited by J.T. Bonner. Copyright © 1961 Cambridge University Press. Reprinted with the permission of Cambridge University Press, p.28

All photographs by the author except as follows:

Sunny Grewal: Photographs of origami models, throughout, except Moon and Forest Troll; teacups, p.30; bottle and wooden mold, p.32

New York State Department of Tourism: Origami Lighthouse and Mountains, p.20

Quesada/Burke, New York: Origami Elephant, p.21

Cheryl Perko: Phone booth with New Yorkers, p.20

Kate May: Photo of author

Library of Congress Cataloging-in-Publication Data

Engel, Peter, 1959-
 Origami odyssey : a journey to the edge of paperfolding / Peter Engel ; with an introduction by Nondita Correa-Mehrotra.
 p. cm.
 ISBN 978-0-8048-4119-1 (hardcover)
1. Origami. I. Title.
 TT870.E544 2011
 736'.982--dc22
 2010049041

Contents

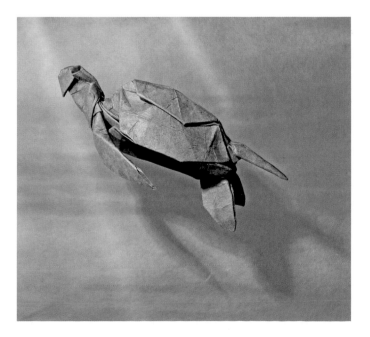

■ intermediate ◆ more difficult ▲ most challenging

Foreword

by Nondita Correa-Mehrotra

How wonderful it is to fold a simple square sheet of paper! A square is perhaps the purest shape, and through the elementary act of folding this sheet, we can create an object. There are no implements, no tools for measuring. This is why the origami models I enjoy most are those that clearly relate back to the square paper I began with, like the elegant crane we all learned to make. The steps to create it are few and the time taken so little that I am amazed at how quickly I can craft this bird!

However, as one progresses to the more complicated models, like the complex insects with perfectly proportioned legs and antennae, the skill and deftness required can often be very demanding. That, I suppose, is what defines the more advanced paperfolder from the beginner. Yet, what fascinates me about origami is not necessarily that kind of complexity. Rather, it is the straightforwardness that I strive to find, the purity in the ideas that created it. The ideas I am talking about are really ones that a paperfolder infuses into his model—be they ones that push the medium of the paper and the rigor of the folds, or, as Peter Engel eloquently describes in his essay in this book, "the spirit." And when you see origami in this context, you realize that in simplicity there is simultaneously a surprising complexity, running like an undercurrent, stemming from the ideas that the folds and processes explore. It is important to define these ideas, for as Henri Matisse said, "Much of the beauty that arises in art comes from the struggle an artist wages with his limited medium." This is so true of origami, as the medium is extremely limited, the parameters tight. The one thing in our control is the folding itself.

Of course, one of the most beautiful and gratifying aspects of origami is undoing all the folds and analyzing the square again. It is abstract, yet clearly has an intense correlation between what you had just made and the process of folding. The sheet unfolds almost flat, but for the folds that once were. "A fold changes the memory of the paper," explains Erik Demaine, a mathematician and one of the world's foremost theoreticians on origami. The memory of the paper—that's a beautiful thought!

And when the paper is unfolded and yet carries the memory of the first set of folds, could we use it to make a completely different object, with a different set of folds? Like a palimpsest, if we were to reuse the once-folded sheet, how would one pattern, one set of instructions influence the other? What happens to the new

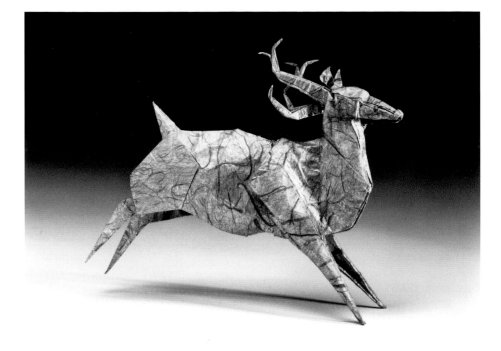

As remarked by Correa-Mehrotra, a folded sheet of paper records a memory of the folding process. Shown at left the author's origami Reindeer and above the pattern of creases that results when the paper is unfolded. The dense pattern of lines at top corresponds to the nose, ears, and antlers.

object? In my mind, I understand the folds and the memory of them on the square sheet of paper as being the dominating mechanism in origami.

Whatever we make, whatever models we construct, we learn from them, and in turn we can better what we make. In his essay, Engel talks about connecting oneself to one's craft, and as both an architect and a paperfolder, he is able to relate these sensibilities to his models. We each try and relate what we make to what we know. As an architect I feel that unfolded, flattened paper, with its creases yet visible, reminds me of an architectural plan—from which I can understand the structure and the nuances of the object. Yet a difference does exist, for there is a physicality prevalent in origami that is missing in architectural orthographic drawings. The fact that the paper has to be folded manually is a tactile exercise, one that forces us to think the process through.

For several years I taught an architectural undergraduate design studio in which one of the assignments was to make what I called a "lightbox." It was a mechanism for capturing light and was made by the students from a single sheet of white Bristol board paper. The sheet size came in 22.5" x 28.5" and they were required to use the entire sheet. Although they were allowed to cut and fold, they could not use any adhesive. Only the folds had influence and stiffened the structure. The students made amazing forms and watched how light behaved without and within. And finally when we unfolded the "lightboxes" to understand the process, the paper recounted to us its memory!

This exercise also introduced the concept of economy of material, of using every part of the sheet—something origami is so rigorous about. As Engel says in his essay, while other art forms are either additive or subtractive, "origami is transformative." And he rightly, I think, compares this attribute to alchemy, for there is as much material at the beginning as at the end, and so you can go back to the beginning without losing anything. This capacity to create something with care and determination (and no waste) is unique. Without that objective, that intent

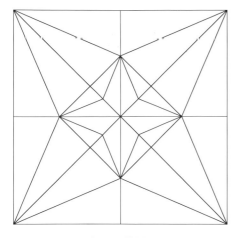

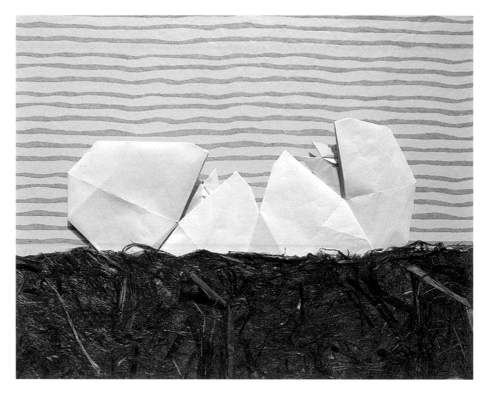

The author's origami Hatching chick, shown at right, and the memory of its folding process, captured in the crease pattern above. The white egg opens to reveal the yellow chick, produced from the opposite side of the paper.

to create something of consequence, you could just as easily scrunch up the paper and call it abstract art!

Nondita Correa-Mehrotra
Boston
October 2010

Nondita Correa-Mehrotra, an architect working in India and the United States, studied at the University of Michigan and Harvard. She has worked for many years with Charles Correa Architects/Planners and is also a partner in the firm RMA Architects in Boston.

Correa-Mehrotra has taught at the University of Michigan and at the Massachusetts Institute of Technology. She was one of five finalists for the design of the symbol for the Indian Rupee, an idea she had formulated and initiated with the Reserve Bank of India in 2005. She also designs furniture, architectural books and sets for theater, and curates exhibitions.

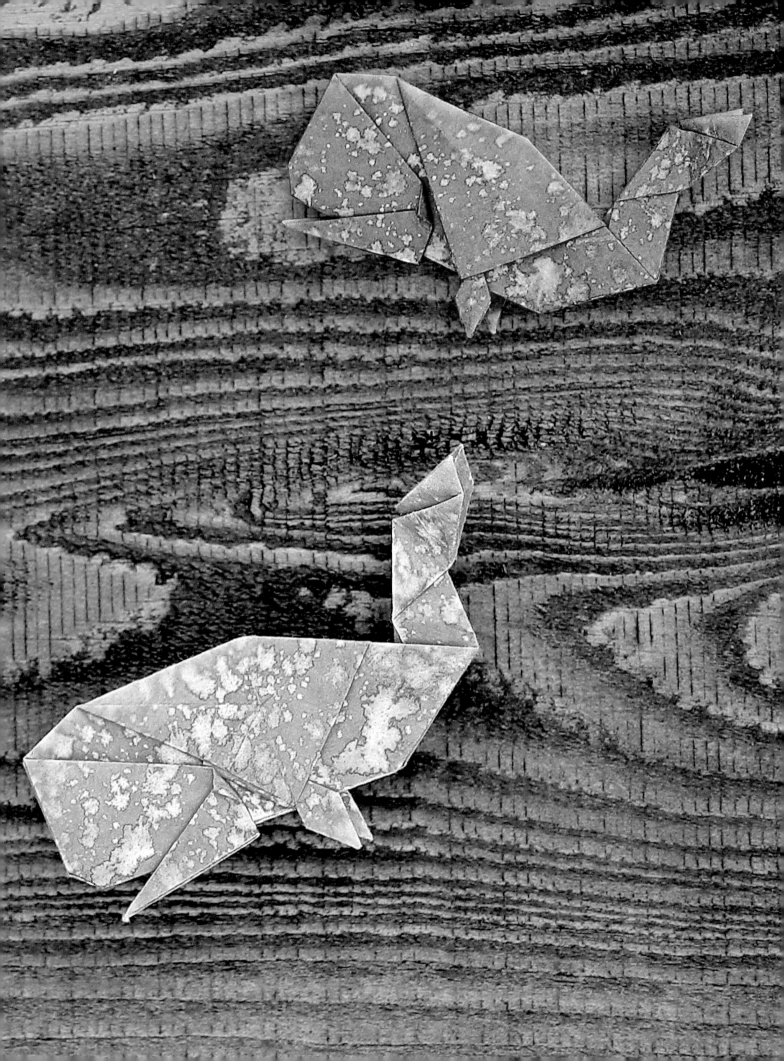

Preface

Creating the origami designs and thoughts that fill this book has been a personal odyssey spanning two decades. At the time I finished my first origami book, in 1989, I had been creating original origami designs (paperfolders call them "models") for over 15 years. I was proud of them, but they felt like the work of a child and a student, not someone of the world. Since that time, I have traveled to a dozen countries in Asia, for work and research; traveled the path of marriage and parenthood; and traveled deeply within myself as I questioned the relationships among art, craft, nature, music, and philosophy, and, especially, what this strange art/craft/pastime of origami means to me. These journeys have taken me to a place I consider to be the edge of paperfolding. In this book, I invite you to follow me there.

If you are new to origami, or even if you consider yourself a veteran, be prepared to traverse some very challenging territory. Some of these models are among the most complex ever published. (Although my design aesthetic tries to make a virtue of simplicity, getting to simplicity is often complicated.) Even highly experienced folders may find that it takes more than one attempt to produce a satisfying result. In the Table of Contents, the models are rated in order of difficulty from blue square (intermediate) to black diamond (more difficult) to yellow hazard triangle (can't say I didn't warn you).

The models in this book can all be made from commercially available origami paper, such as the approximately 10-inch squares found at arts and crafts stores, although I strongly encourage readers to experiment with larger and higher-quality art paper. Handmade Japanese *washi* paper comes in a myriad of textures, styles, patterns, and colors, is durable, and if molded when damp (misted with a plant sprayer) or coated with a thin paste of starch or methylcellulose (a safe and readily available thickening agent) retains its shape when dry. Useful tools include a burnisher (any hand-held tool with a flat edge or tip; hardware stores often stock metal ones that resemble dentist's tools), and tweezers with an elongated tip. To fold a model of a given size, calculate the size of the initial square from the information given on the first page of each set of diagrams.

When you behold your finished models, having completed the long and rewarding journey from step one to the final destination, say a word of thanks to my friend and artistic collaborator Mao Tseng, who transformed my rough hand sketches into the beautifully rendered drawings presented here.

Welcome to the edge of paperfolding!

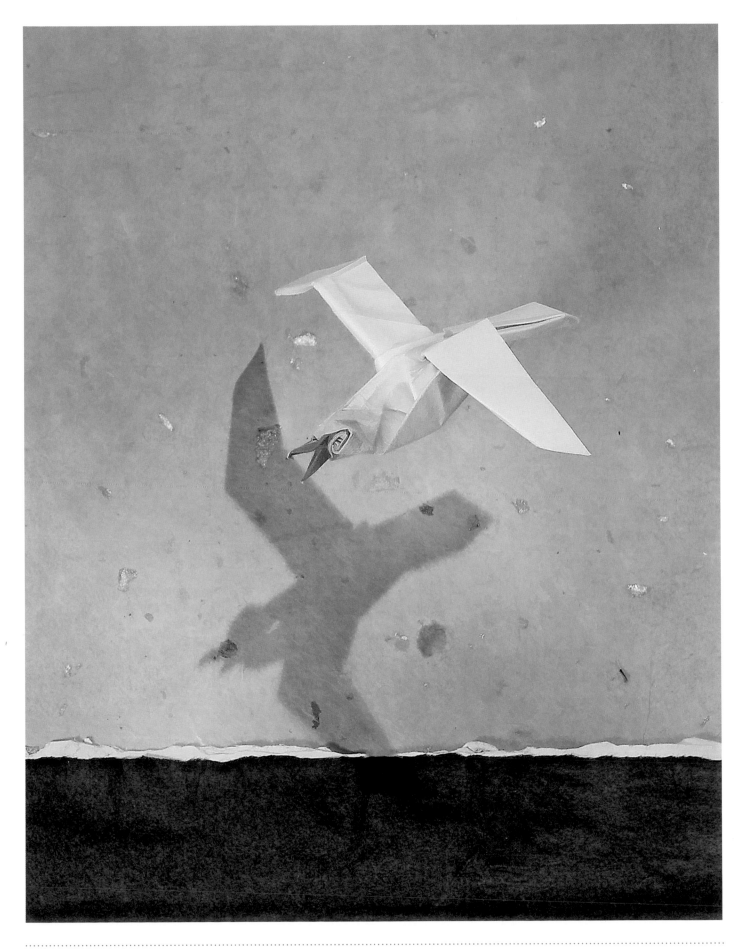

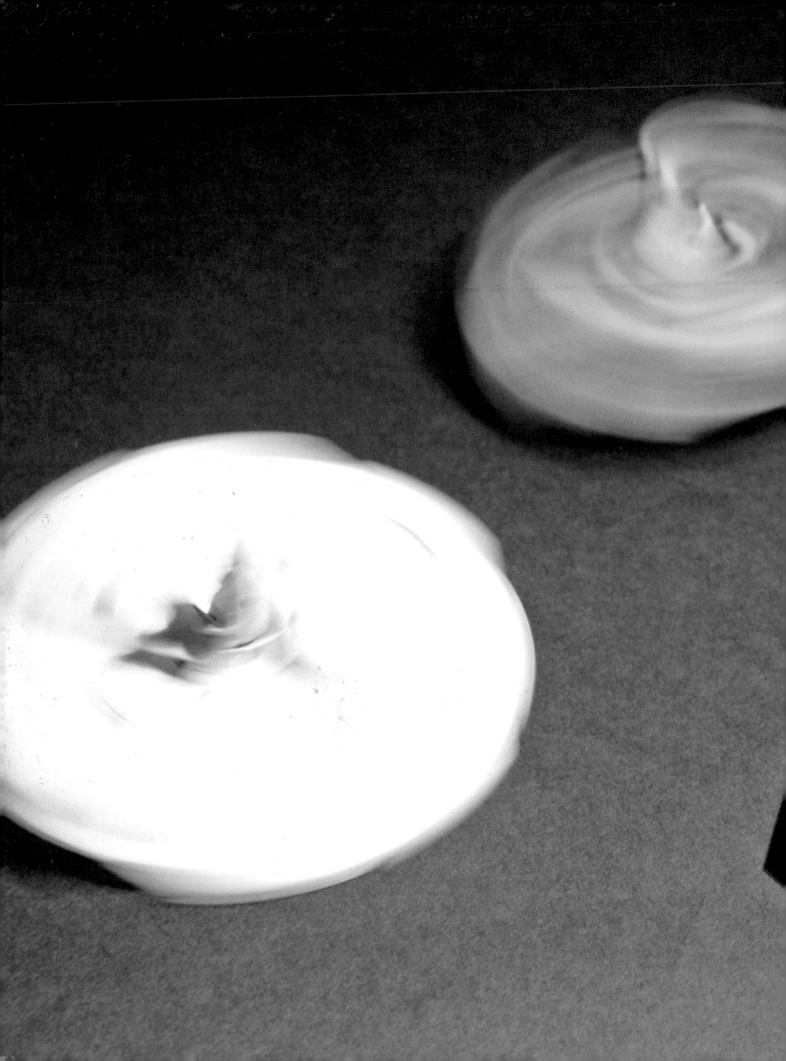

Introduction

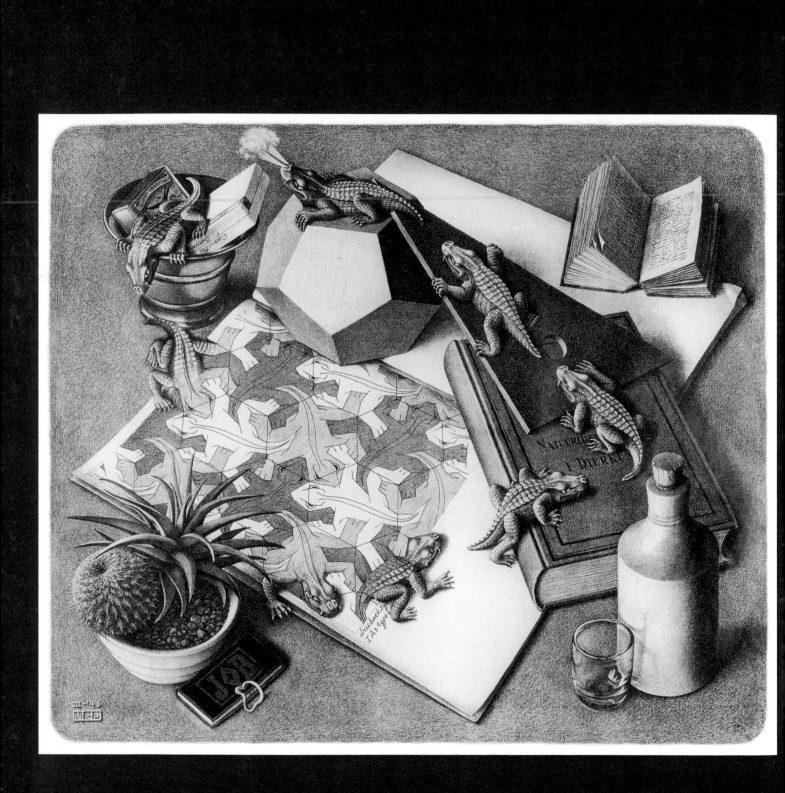

In Search of Form and Spirit:
An Origami Odyssey

Why am I—and why are you, the reader of this book—drawn to origami? There are, after all, more popular arts we could pursue: painting, sculpture, photography, poetry, dance, or music, each possessing a fine Western pedigree. When I was a child of twelve or thirteen, just developing a fascination with paperfolding, I didn't question what drew me to it. I only knew that with each new figure that formed in my hands (at first other people's designs, and then my own), I felt the pull of having entered some other, deeper world.

I didn't have the words then to describe this experience, but today I would say that it involves magic, alchemy, the transformation of something common (a piece of paper) into something rarer than gold—something living, a bird or a beast or a human figure. Some arts are additive: an oil painting is built up stroke by stroke, a musical composition note by note, a work of literature word by word. Others—a woodcut, a stone carving—are subtractive: the artist strips away wood or stone until the desired end state is reached. But origami is *transformative*. There is just as much material at the beginning as at the end. Unfold the completed origami figure, achieved entirely without cuts, glue, or other impurities, and you return to the original square. If that's not alchemy, nothing is.

The Dutch artist M.C. Escher, one of my early influences (I remember being mesmerized by a lithograph of his in a magazine around the time I encountered origami), had an expression for what drew him to the tile patterns that he transformed, bit by bit, into representational figures. He called it "crossing the divide," the divide between that which he called "mute"—meaning abstract, geometric shapes—and that which "speaks," something living and breathing. Escher's artistic process gives life, gives breath. The geometric shape turns into a fish, then a swan, flies from the paper, then returns to become a shape once again. Alchemy.

Escher's philosophical musing has a parallel in a wood-block print by Katsushika Hokusai. In *A Magician Turns Sheets of Paper Into Birds* (1819), the pieces of paper tossed into the air by a seated magician evolve into a more and more bird-like form until at last they take flight. Hokusai, like Escher, brings the inanimate to life. By crossing the divide in the other direction, however—returning animate forms to their abstract, geometric origins—these artists simultaneously under-

Given the breath of life by M.C. Escher's extraordinary imagination, this mischievous reptile aspires to live in three dimensions but is condemned to return to the inanimate tile pattern whence it came.

Katsushika Hokusai's wood-block print *A Magician Turns Sheets of Paper Into Birds* captures the alchemical transformation that takes place in the creation of an origami model.

mine the reality of their creations' existence. In Escher's lithograph *Reptiles* (1943), the lizard that emerges from a hexagon thinks it is alive—in Escher's exquisitely rendered image, it appears completely three-dimensional and palpable, and even gives a little snort—but before long it becomes two-dimensional again and then mutely, and meekly, regresses to the hexagon whence it came. If the lizard isn't real, how do we know that we are?

In my teens and early twenties, I was captivated by form and pattern, and the origami models I devised during that time aspired to geometric perfection. In my designs from that period, such as a lumbering elephant, a leaping tiger, a prancing reindeer with a full rack of antlers, a scuttling crab, and a sinuous octopus with eyes and a funnel for shooting ink, I strove to discover the seemingly limitless potential contained within a single square of paper. (These models appear in my first book, *Folding the Universe*.) To generate figures as elaborate as these, I drew on an age-old tradition in paperfolding, adding layer upon layer of complexity to basic forms devised by the two cultures that elevated paperfolding to a high art, the ancient Japanese and the Moors of medieval Spain and North Africa.

The square, with its many symmetries, lends itself to capturing these complicated but ultimately symmetric shapes. I applied geometric operations such as reflection, rotation, change of scale, and the grafting of one pattern onto another to generate complex forms from simple ones. Unfold any of these models to the original square, and the profusion of legs, tusks, antlers, tentacles, and antennae melts back into an orderly, geometric pattern. Indeed, it has to, or the paper would not fold compactly enough to produce so many long, thin appendages. Out of this structural need for efficiency is born origami's aesthetic of economy. Indeed, the pattern visible in the unfolded sheet is striking and beautiful.

These early models made a virtue of rigor and a kind of determinism. The more the completed design appeared inevitable—the more the entire model appeared to develop from one initial impulse, without a single crease left to chance—the more I prized it. In writing about the virtue of geometric rigor in *Folding the Universe*, I drew a parallel to the well-wrought piece of Western classical music. The first movement of Johannes Brahms's Fourth Symphony, which I cited as an example, unfolds inexorably, and thrillingly, from the very first two notes, then develops, recapitulates, and culminates in a shattering climax. It is still a piece I love, and even today, artistic rigor, whether in music, architecture, or origami, exerts an enormous pull on me, and is reflected in some of the models in this book.

A Japanese Pilgrimage

I had already spent a decade creating my own origami figures when, at the age of twenty-three, I traveled to Japan to meet and interview that country's greatest origami artist, Akira Yoshizawa. (The interview appears in *Folding the Universe*.) Without Yoshizawa, whose brilliance and fame popularized origami and made it an international art form, folding paper might still be solely the province of Shinto priests, the Japanese aristocracy, and Japanese schoolchildren.

In the style of a young apprentice to an aged *sensei*, or master (Yoshizawa was then about 70), I drank from Yoshizawa's pool of ancient wisdom, even as I remained skeptical of his mystical pronouncements. As a recent college graduate

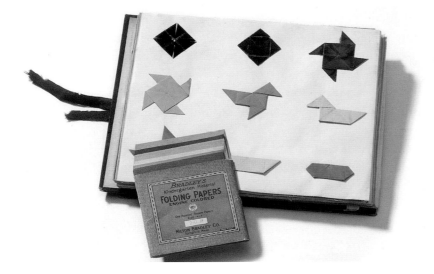

on that first trip to Japan, I was seeking life experience, a way of moving beyond the limitations of an insular life spent mostly in studies. Like many young graduates, though, I simultaneously cast a critical eye on patterns of behavior different from my own, and Japanese culture had plenty to critique. The elder Japanese origami *sensei* whom I met on that visit (Yoshizawa among a half-dozen or so) seemed eccentric in their single-minded devotion to folding paper and narcissistic in their need to surround themselves with true believers who only practiced their particular school of folding. But there was no denying the brilliance and vitality of Yoshizawa's models and of the man himself (in person, jumping up on a table to retrieve boxes of models on high shelves, or imitating the movement of an octopus, he didn't seem old at all), and I began to open up to the wisdom he had to offer.

Years later, I realize that the lessons of that first trip to Japan have never left me. Yoshizawa taught me to listen to nature (water always knows which way to flow); to know both who you are and where you want to go (a compass is no good if you don't know your destination); to heed the interconnectedness of all things (all living creatures inhale the same air); and perhaps most importantly, always to seek the hidden essence, since what we experience with our senses is just the surface, a thin veneer. It is no stretch to see a connection between Yoshizawa's Zen musings on the impermanence of all things (among them, paper) and the short-lived earthly existence of Escher's lizard, with its endless cycle of birth, death by geometry, and rebirth.

I found echoes of Yoshizawa's deeply felt beliefs in the other Japanese arts and crafts I encountered on my journey, all of which resonated deep within me. Like origami, they cultivate an aesthetic of understatement, of suggestion. Just as a three-line haiku evokes a setting or a season, the glancing stroke of an ink brush potently realizes a craggy mountain peak or an aged hermit, and the placement of a rock and a pond in a Zen garden recalls the universe. It is a short imaginative leap from the rock to a mountain, from the pond to the sea.

The ink on the paper and the rock in the garden appeal to us as beautiful *forms*, but I have come to realize that what really captivates us is something subtler and deeper—for lack of a better word, their *spirit*. We sense that there is something mysterious and profound going on, that these forms are really a window to a layer beneath. There is a tenuous balance between form and spirit. If the

top left: Play is at the heart of every origami design. The sheer delight of bringing a form to life in your hands, common to child and artist, breathes spirit into the creation. When the unconscious takes over, play begins. Forward-thinking educator Friedrich Froebel, the inventor of Kindergarten, understood the value of play in learning and made paperfolding a core component of his curriculum.

top right: Play and tradition merge in this image of a folded crane on a Japanese *noren*, a cloth hanging.

Proud as a peacock, origami master Akira Yoshizawa retained his childlike sense of play into his 90's. Here, in his early 70's, he shows off one of his favorite origami creations at our first meeting thirty years ago.

outer layer takes itself too seriously—believing itself to be too real, like Escher's all too self-important and too three-dimensional lizard—it risks having its own reality undermined. The gravel and rock garden at Ryoanji Temple in Kyoto is profoundly powerful and suggestive in a way that an American miniature golf course, with its "realistic" miniature buildings and tinted blue waterfalls, is not. Likewise, an origami model that is too real, too exacting, loses the illusion and the charm—and, with it, the alchemy.

I can probably trace to this first journey to Japan my subsequent, lifelong immersion in Asian art and culture. Research and architectural work have since taken me to India, Nepal, Sri Lanka, Indonesia, China, Hong Kong, Myanmar, the Philippines, and back to Japan. I can hear echoes of Yoshizawa's pronouncements in my fascination with Indian and Indonesian shadow puppets, which come to life only when their shadow is projected on a screen; with the ancient Sri Lankan hydraulic system that irrigated that country's flat dry zone using gravity alone (a version of which my wife and I employed in our design of a peace center in Sri Lanka); with Indian *ragas* that can only be performed at dusk; and with Hindu holy verses that cannot be read out loud, only sung.

Crossing the divide, reality and illusion, interconnectedness, hidden essences, impermanence: I was fortunate as a young man to have been exposed to these enduring and challenging concepts by deep thinkers who made them palpable in their art. These are not qualities American culture values or perhaps even recognizes. As I look around at the state of my country today and our effect on the wider world—our obsessive concern for the here and now, our disregard for nature, our inability to recognize the interconnectedness of all living and non-living things—I see the exact opposite of what Yoshizawa was trying to teach, and it is hard not to be saddened. When Yoshizawa died a few years ago, at the age of 94, I felt a great loss, even as I knew that he would have been the first to remind me how brief is our transit here on earth.

An Indian Journey

Following the completion of my graduate architectural training and the publication of *Folding the Universe* two years later, I took an extended break from paperfolding. *Folding the Universe* proved to be an exhaustive, and exhausting, summation of my early design work and the concepts that had informed it. At the book's completion, I found myself at an artistic impasse—not the first, as the book attests, nor the last. The geometric rigor and determinism that had informed my early designs had come to feel vacant and soulless. Like Escher and Hokusai, I had experienced the illusory nature of aspiring to perfection. And while my exposure to Yoshizawa's artistic philosophy and Japanese aesthetics had reinvigorated me, I had neither the desire nor the cultural background to follow in Yoshizawa's footsteps.

And then the opportunity arose to travel to India. With the aid of several research grants, my wife, Cheryl, and I spent a year criss-crossing the country as she investigated India's extraordinary underground buildings and I researched that country's vernacular architecture, the buildings and places made by ordinary people. As we journeyed through mountains, forest, and desert and from teeming city slums to remote, tiny villages, we were exposed to India's extraordinary crafts

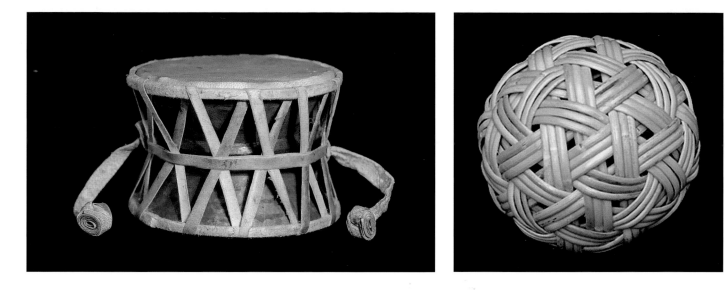

traditions and met some of the country's finest weavers, woodcarvers, brass smiths, potters, bas relief sculptors (to decorate the interior of a desert house, they mold a mixture of mud, straw, and dung), and makers of leather shadow puppets. The work of India's craftspeople possesses a rough, elemental power, often revealing the actual imprint of the maker's own hands.

Meeting these artisans allowed me another opportunity to reflect on the craft of origami and how it had come to be practiced in the United States. The passion, artistic vision, and technical refinement that Indian craftspeople bring to their work are the outcome of centuries-old traditions passed down by word of mouth from father to son and mother to daughter. Each piece of craftsmanship expresses a culture's repository of religion and folklore while simultaneously allowing the artisan a limited amount of freedom to explore his or her own creative ideas. And while the created object is ornamental and decorative, it is also practical: something to be worn, to carry food or water, to create music (the *ghatam*, an ancient south Indian instrument, is a specially fashioned clay pot), to serve in a religious ceremony.

The same could certainly be said of Japanese crafts and of origami as it was practiced in Japan for most of a millennium. But when Westerners took up origami around the middle of last century, they chose to appropriate the technical rather than the cultural aspects of Japanese folding. Such uniquely Japanese traditions as the thousand cranes, the Shinto shrine, the tea ceremony, and the strict master-disciple relationship meant little to the new self-made folders of the Americas and Europe; instead, they seized upon the geometry of the kite base, fish base, bird base, and frog base as if it had always been their own. Western paperfolding began with a powerful set of mathematical relationships but little or no cultural tradition in which to ground them.

I came to realize that my own origami designs fell squarely in the middle of this traditionless Western tradition. Unlike Japanese origami or the crafts I encountered in India, most of my early creations had no historical origin, no set of cultural associations, and no utility: they were objects to be seen, not used. They arose not from a collective, cultural wellspring but rather my own, individualized response to principles of geometry and to creatures that I had seen only in aquariums, zoos, or—stuffed—at the American Museum of Natural History in

Craft requires that the maker of an object respect the nature of the materials at his service. The limits imposed by the size, shape, thickness, and texture of the medium inspire the creator of a pot, rug, tool, or origami design to create an object of function and beauty.

A woven wicker ball from Java, Indonesia and a copper and leather "monkey" drum from Patan, Nepal are two of many crafted objects that have inspired my origami designs. They evoke the spirit of play not only in the finished products but also in their creative design and skillful execution.

Memories of my childhood in New York state brought to life these three scenes of Montauk Lighthouse, the Adirondack Mountains, and a Sailboat in a series I designed for the New York State Department of Tourism. The finished versions were folded from the tourism brochure, and photographs of the models appeared on telephone booths and billboards throughout New York City. The lighthouse cottage appears in this book.

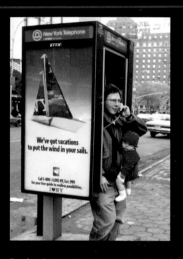

Typical New Yorkers are oblivious to origami design on phone booth.

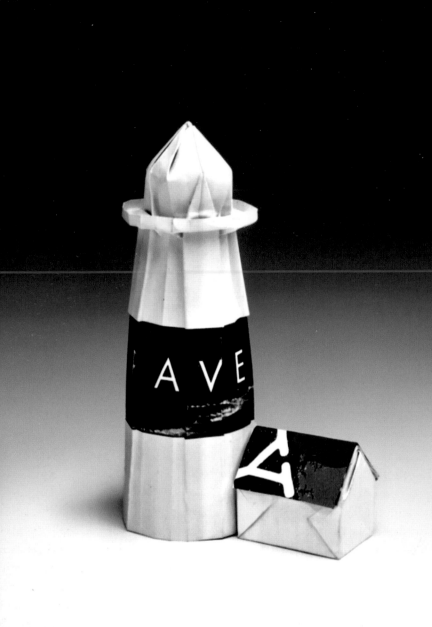

Seen in perspective, the mountains reveal the irregular crags and promontories, the order mixed with improvisation, of their counterparts from nature. They employ a spiraling sequence of closed-sink folds that avoids unnatural-looking horizontal or vertical creases. The folds are similar in shape, but because they rotate and reduce in size with each turn, no two faces of the mountain are the same, and the resulting origami models appear natural and asymmetric.

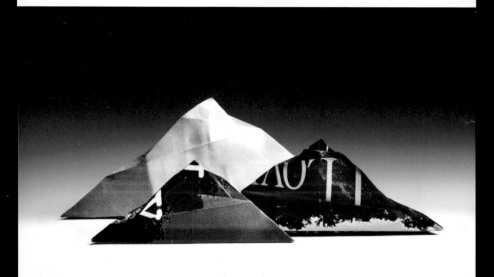

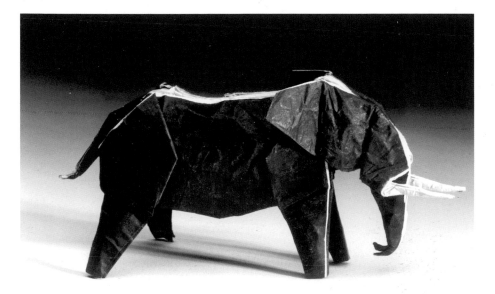

New York City. (In India, the depictions of tigers, elephants, and monkeys are often based on encounters in the wild.) Whatever aesthetic delight my creations afforded the viewer arose from their finished form and the technical ingenuity required to fold them, not from a shared, empathic relationship between the viewer and the creator.

Many of my earlier models exhibit a high degree of symmetry. The pattern of creases in my model of an Elephant reveals mosaics of repeating shapes. The taut geometry reflects an efficient folding process, necessary to achieve the elephant's pointed tusks and tapered trunk (with tiny "fingers" at the tip).

A Mysterious Affinity

Along with Indian crafts, I found myself deeply influenced by Indian music, from the classical *ragas* I heard performed by renowned musicians such as L. Shankar and Zakir Hussain in a Mumbai concert hall to the powerful, rough-hewn folk music I heard sung by the goat- and camel-herders of the plains and deserts. Classical Indian music has a completely different quality than most Classical Western music. Often meditative and dreamlike, it can give the sense of being in motion without going anywhere. Evoking the paradox of the *raga*'s journey, the Indian music critic Raghava R. Menon writes in *Discovering Indian Music*, "Its possibilities are infinite and yet it always remains unfinished. Its ending is always a temporal ending . . . In the immediate present, there is no perfection, no consummation, nothing is finished . . .We can see the invisible in it, laden with mystery and revelation, candidly open in its transit . . . It does not want to get anywhere. It just takes place."

In contrast to the perfection and inevitability of a piece of Western classical music like Brahms's Fourth Symphony, whose entire score is written out note by note for the musicians to perform, an Indian *raga* is always improvised. A *raga* begins with the sound of a *tanpura*, or drone. There is as yet no rhythm, no measured beat, no pattern. One could say the drone is the sound of the universe before the beginning of time. Out of this hallucinatory mood emerges a second instrument, possibly a *sitar* or *sarod*, which weaves melodies hypnotically in and around the drone. And then, with the introduction of the *tabla*, with the first drum beat, comes the beginning of a kind of order. It is a very complex order, with highly varied patterns of beats that initially sound quite strange to Western ears. Other musicians enter, and the *raga* becomes a dense, polyphonic intermingling of

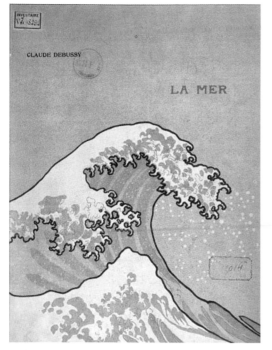 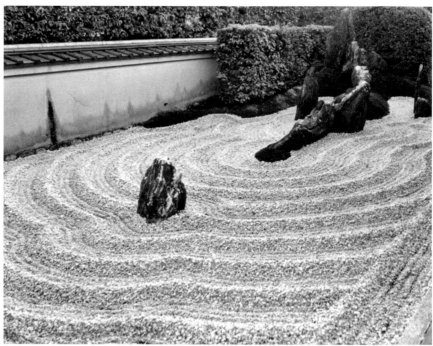

Using imagination and the power of suggestion, two Japanese artworks evoke differing moods of water: a raked-gravel Zen garden and an interpretation of Hokusai's wood-block print *View of Mount Fuji Through High Waves off Kanagawa* from the cover of Claude Debussy's printed score for *La Mer*. Debussy owned a copy of the print and chose the image himself.

voices. Like a piece of Western classical music, a *raga* has a complex structure, but the structures are completely different, reflecting the very different relationships in India and the West between man and nature. Menon writes, "The Indian ethos postulates the existence of a reality behind the appearance of things, a mystery that lurks in the core of all created things," and goes on to add, perceptively, "The delight of Indian music, then, lies in the search for this elusive, mysterious beauty, not in its 'finding.' If this delight is transferred to the 'found' beauty from the search for new beauty, a sudden loss of vitality, a facile sweetness begins to show, and a superficial estheticism takes over." It is not hard to hear, in Menon's description, echoes of Yoshizawa's belief in unseen essences and beauty that can only be found beneath the surface.

My exposure to Indian crafts and music gave urgency to my struggle to escape the hegemony of geometric determinism in origami. I gained conviction, too, from the music and writings of a couple of Western classical composers whose works I had loved but perhaps not fully understood. Western composers began to absorb Asian influences into their music at the end of the 19th century, a time when the French composers Claude Debussy and Erik Satie struggled to break free of the Germanic determinism that had dominated classical music from Beethoven through Brahms and Wagner. While some British and Central European composers looked to native folk traditions, Debussy and Satie turned primarily to inspiration from ancient Greece, medieval mysticism, and the exotic sounding harmonies and rhythms of the Far East.

Although Indian music was little known, the appearance of a Javanese gamelan orchestra at the 1893 Paris Exposition had a mesmerizing effect on Debussy. A keen collector of Japanese woodblock prints and other Asian *objets d'art*, Debussy began to experiment with the pentatonic scale (Satie was doing much the same with medieval scales), generating indeterminate and unresolved harmonies that possessed, in common with much Asian music, a kind of static motion. Much of the music that Debussy produced has subtle correspondences with nature and

human experience—famous examples include the piano works *The Sunken Cathedral, Pagodas, Evening in Granada, Goldfish, Reflections in the Water,* and *Gardens in the Rain,* with perhaps his most famous work being the orchestral *La Mer (The Sea)*—but he rejected the notion that he was a mere "impressionist," preferring to think of himself instead as a "symbolist." In an incisive note about the creation of his opera *Pelleas and Melisande,* Debussy wrote, "Explorations previously made in the realm of pure music had led me toward a hatred of classical development, whose beauty is solely technical . . . I wanted music to have a freedom that was perhaps more inherent than in any other art, for it is not limited to a more or less exact representation of nature, but rather to the mysterious affinity between Nature and the Imagination."

Working nearly in parallel with Debussy, Satie was exploring the balance of stasis and movement in his own piano pieces and songs and undermining the seriousness of the Germanic tradition by marrying his profound mysticism to an absurdist sense of humor. He provocatively titled a set of piano compositions *Three Pieces in the Form of a Pear* to prove to his close friend Debussy that his music really did have form. (Pointedly there are seven, not three, pieces in the collection.) The same Zen-like mind later produced *Vexations,* which consists of a single musical theme repeated 840 times. Satie's "white music" and Zen utterances would eventually inspire the aleatoric, chance-inspired music of the American composer John Cage, who with a team of pianists first performed *Vexations* seventy years after it was composed, in a performance that took over 30 hours. Satie's deliberate disconnect between the name given to a piece of music and the music itself recalls the paradoxes evoked by Escher's reptile and Hokusai's magician, calling into question which is reality and which illusion.

For an origami artist, whose works often draw their inspiration from objects and experiences in nature, Debussy's distinction between "a more or less exact representation of nature" and "the mysterious affinity between Nature and the Imagination" is critical. One is concerned merely with surface appearances (the "lifelike" waterfall at an American miniature golf course), the other with resonances deep within the human psyche (the Japanese Zen rock garden, the Indian *raga*).

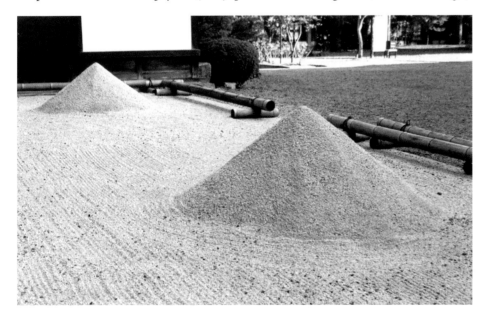

This Japanese Zen garden powerfully employs raked gravel and a bamboo perimeter to suggest far more than it states outright. Why shout when you can whisper?

The intention of the artist is thus not to "represent" nature, but rather to explore the *terra incognita* wherein lies Debussy's "mysterious affinity." As the contemporary pianist and critic Paul Roberts has written in his book *Claude Debussy*, "La Mer is not only an impressionistic evocation of the sea, a surface shimmer; the work is a transmutation of mankind's complex and subconscious responses to the sea, achieved through and within the very pith of the musical material . . . For Debussy the sea is already a symbol. His music is another, a symbol of a symbol."

I wondered, could an origami model be, likewise, a symbol of a symbol?

Sun, Moon, & Stars

A few years after Cheryl and I returned from India, I sought a subject for an origami mobile to make our soon-to-be-born daughter, Hannah. I hoped to capture the wonder of the world as it is seen through a baby's eyes: a world not of neutral scientific phenomena, like the animals I had modeled for my early designs, but of highly charged images and emotions, where every face evokes primordial memories of mother and father. I reflected on my new-found understanding of the crafts tradition, of Indian classical music and the lessons I had learned from Debussy and Satie, and remembered the time I had spent in India with the goatherds of the Thar desert, nomads who travel at night through a nearly featureless landscape with only the orientation of the constellations and the light of the full moon to guide them. For them, the sun, moon, and stars are more than just scientific phenomena: they are the signposts of their daily lives, commanders of the cycle of seasons, reminders of a mythic past that is relived daily through religious and astrological beliefs.

Attempting to see the world through a baby's eyes made me realize that there is indeed continuity between the Indian craft tradition, a world of symbols and resonances, and my own. In the highly charged world of the infant and the craftsperson, each natural or manmade object is imbued with purpose and meaning beyond its mere surface appearance or scientific structure, spirit beneath the form. Surely the sun is not just another mid-sized star comprised of hydrogen and helium, but a face with round cheeks and pouting lips; surely there is a man up there in that sliver of moon! Only the most unimaginative stargazer could imagine them to be uninhabited.

I completed the mobile of the Sun, Moon, and Stars by the end of October, just in time for my daughter's birth a week later. Inspired by my encounters with Indian craftspeople, the resulting models display more life and call for a more intuitive approach to the paper—exhibiting the actual imprint of the folder's hands—than any of my previous designs. During Hannah's first few weeks of life, I came to realize another level of meaning to the sun and moon hanging from the ceiling above her head. I tried to imagine what her perception must be of Cheryl and me, as we hovered above her, two shadowy figures providing her warmth, milk, sound, touch, and smells. Could she know that we were two human beings like her, just a little older and, perhaps, wiser? Or, more likely, were we not people at all but the entire universe—the sun and the moon, the planets and the stars, the earth and the heavens? In the weeks and months that followed, Hannah's cosmos slowly assumed human form, just as she began to make out the faces in the origami figures that twirled above her head. In the years since, she has figured out that

Cheryl and I are but human beings after all. But I hope that whenever she looks into our faces she will always see the sun and moon smiling back.

Soon after Hannah entered the world, my friend and fellow paperfolder, Mark Turner, died of AIDS. Mark had opened my eyes to the beauty of the plant world through his extraordinary origami designs of flowers, leaves, and trees. In the last few months of his life, he furiously devoted his energies to creating new plant forms. Plants are a particularly challenging subject for origami. Their slender branches and stems, rounded leaves, shaggy fronds, and varied branching patterns constitute a poor fit for the taut geometries of the square. But in what appears to be a single, sustained burst of invention, Mark originated a highly individual approach to folding and then, with the fastidiousness of a botanist, pursued its implications from family to family and species to species throughout the plant kingdom. His sensuous, curving plant forms breathed new life into the familiar technique of box-pleating, which once seemed destined to produce only replicas of matchboxes and modular furniture, the mechanical handiwork of man. (Examples of box-pleating from this book are the Sea Turtle and Cottage.) And with Mark's choice of such eclectic models as a trumpet vine, a gnarled oak, and a plant-filled cornucopia, he reminded me that origami's potential for new subjects knows no bounds.

An Origami Tribute

The juxtaposition of Hannah's birth and Mark's death was intense and powerful. I knew that I needed to make an origami tribute to Mark, and I chose as my subject a leaf from a tree with deep spiritual significance, one which I had come upon frequently in my South Asian travels: *Ficus religiosa*, known in Sri Lanka as the *bodhi* tree and in India as the *pipal* tree. The *bodhi* leaf is extraordinary. It has an unusual and beautiful shape, with a long, attenuated tip and an asymmetric branching pattern. Twenty-five hundred years ago, the Buddha attained enlightenment while meditating beneath the canopy of a *bodhi* tree. Since that time, the *bodhi* tree has been cultivated throughout the Buddhist and Hindu worlds as a symbol of nirvana,

bottom left: The patterns of nature are a union of two opposing forces, order coupled with improvisation. In the balance of the two lies the beauty of mountains, clouds, trees, rivers, animals, crystals. The beautiful origami model seeks the same harmony.

below: The cracks in the glaze on an earthenware pot and the cubic volumes of houses in Jodhpur, India display order but no symmetry.

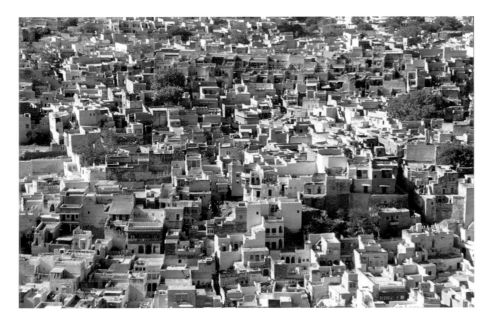

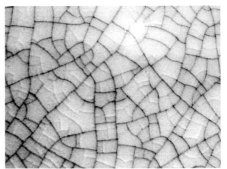

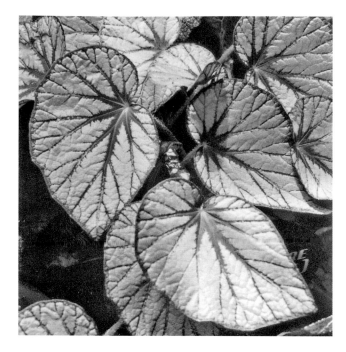

The curious asymmetry of the begonia leaf, shown here in a plant from Peradeniya Botanical Garden in Sri Lanka, inspired me to design an origami model of the leaf.

relief from suffering, which can only be attained by following the *dharma*, the code of thought and conduct laid out by the Buddha. Like the banyan, another ficus, the *bodhi* tree is remarkably resistant to the burning heat of the tropics. It is often planted in a village square or a temple ground with a stone platform erected around the base of its trunk to provide seating beneath its shady canopy.

Like the Sun, Moon, and Stars, the prospect of designing an irregular *bodhi* leaf challenged my preconceptions of what could be done with a square of paper. While the square clearly offers a treasure trove of symmetric patterns suitable for birds, mammals, insects, and simple flowers, most natural forms are, as Mark had discovered, full of imperfections: asymmetric leaves, twisted branches and vines, gnarled trunks, varied and ever-changing cloud formations, the mottled coloration of hair and fur, the ragged chasms and promontories of a mountain chain. The branching of trees and of river deltas, the dividing of cells and of soap bubbles, the multiplying of whorls in water and of puffs in a cloud, the cracking of mud and of eggshells, and the slow accretion of crystals and of chambers in a snail shell are all examples of forms that are coherent even though they lack clear-cut symmetry.

As an example of how irregular patterns occur in nature, consider the cracking of a drying drop of oil. (A photograph of a cracking oil drop appears in *Folding the Universe*.) First we behold the fluid, formless drop. Outside, its black skin glistens; within, its molecules swim in a vast, slippery sea. Now the drop falls; it lands on a smooth, flat surface and slowly dries in the sun. As time passes, it contracts and cracks. At first, there may be only a single, large fracture that extends in a crooked arc across the surface of the shrinking oil. Then, smaller fissures occur. They meet the first fracture at angles that are close to perpendicular, but never exact. As the oil continues to constrict, dry, and flake, still smaller lines appear, bent and fragmentary, filling the empty gaps left by the earlier cracks. The result is a complex and beautiful pattern—an irregular pattern—that is poised somewhere between order and improvisation. The photograph on page 25 showing the cracked glaze on an earthware pot reveals a similar pattern.

Thinking about creating the *bodhi* leaf led me to contemplate the irregular forms of the ancient South Asian communities where I had come across them. Take a second look at the pattern of cracks in the dried oil drop or the earthenware pot and imagine, for a moment, that you are in an airplane looking down at the ground. What do you see but the myriad patterns of human habitation— boulevards and avenues, streets and alleys, the entire circulation network of an ancient human settlement. The resemblance to an aerial view of an Indian desert town is uncanny. In stark contrast to the rigid, highly geometric forms of most contemporary housing designs, the ancient human communities that I visited felt as natural as the actual products of nature.

What do these similarities tell us? Are they merely accidental, or do they reveal a larger truth about the forms created by nature and by man? My research revealed that while traditional settlements vary tremendously with region, culture, and climate, they are nonetheless the product of a few consistent

environmental and social patterns. Like the cracks in the drying oil drop, most traditional communities are formed incrementally, through many small modifications and interventions, over a prolonged period of time. A settlement may begin along a single path connecting two nearby towns or the center of a town with a well or a watering hole. As the settlement grows, the path may be enlarged or paved to form a street, and a bazaar may form along its sides; new footpaths may be added that extend in opposite directions, connecting the street to a new temple, church, or mosque; additional homes may be built by individual families who are migrants to the town or the children of the original settlers. Over a period of time, families expand, families divide, the community expands, the community divides, and the buildings and streets multiply. Through this process of expansion and partition, the community takes the form of its maturity.

The beauty I had found in the imperfection of Indian crafts and music, in natural forms, and in ancient human settlements, laid to rest whatever commitment I still maintained to the well-wrought, purely "deterministic" work of origami, the one that unfolds inexorably and inevitably from solely geometric principles. The imperfections in a natural form or human settlement demonstrate that the pattern was not hewn in a single masterstroke. In the dried oil drop, for example, none of the areas of dried oil is square, but almost all have four sides. The cracks meet not at perfect right angles, but nearly so. Even that most repetitive of natural processes, the transcription of genetic information by DNA, is never perfect; the resulting mutations create the genetic variations that allow species to adapt and survive.

The bodhi tree, *Ficus religiosa*, has great significance for Buddhists and Hindus as the tree under which the Buddha attained enlightenment while meditating 2500 years ago. *Below*, leaves from a tree in Sri Lanka. *Left*, my origami model of a bodhi leaf, shown in silhouette. It was designed to commemorate the life of a friend and paper folder, Mark Turner, who died of AIDS.

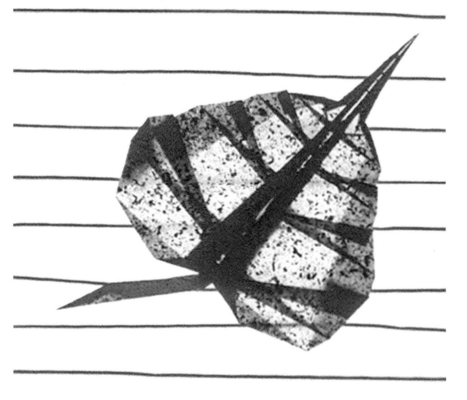

Designing the Bodhi Leaf

Having seen the role that order and improvisation play in shaping Indian crafts and music, the forms of nature, and the ancient settlements of man, I concluded that the Bodhi Leaf model would have to contain both systematic and random elements, and that it would begin with a symmetric structure and move gradually toward asymmetry. It would not be my first asymmetric model—the coiled Rattlesnake in *Folding the Universe* employs a spiral form—but it would require paying greater respect to the improvisations of nature, the erratic shapes and subtle curves that mark a form as organic and natural instead of machine-made and mechanical. And it would need to capture the mysterious affinity between an actual *bodhi* leaf and one of the imagination.

Breaking symmetry did not prove easy! After considerable exploration, I realized that to stagger the placement of the veins along the leaf's central spine would require shifting the paper up on one side while shifting it down on the other. Drawing on what I had learned from the Rattlesnake, that asymmetry can result from layering different types of symmetry upon each other, I introduced a small rotational symmetry within the larger mirror symmetry of the leaf, escaping from the plane of the paper into the third dimension. The opera-

A sketch from my travels (*upper left*) and a diagram by British biologist D'Arcy Thompson (*upper right*) independently analyze the begonia leaf's broken axis of symmetry, which appears to result from differing rates of concentric and radial growth. Thompson applied his understanding of the growth of symmetric leaves, captured in the elegant diagram (shown below).

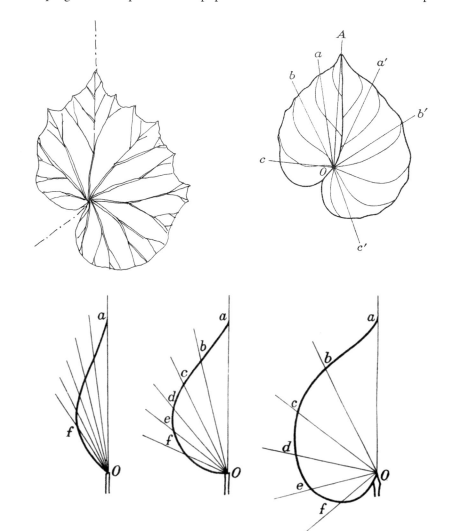

tion is a kind of pinwheel. With echoes, perhaps, of Escher's reptile, it begins by lying flat within the plane of the leaf, lifts out of the plane in order to rotate either clockwise or counterclockwise, and then collapses back into the plane when its work is finished. Just as the third dimension is required to turn a right-handed handprint into a left-handed one, the third dimension turns out to be a prerequisite for making the Bodhi Leaf asymmetric. This systematic sequence of pinwheel operations, combined with a more improvised and intuitive placement of the veins of the leaf, gives the finished Bodhi Leaf the elusive and intangible quality I had desired.

Completing my tribute to Mark Turner freed me to explore the form of other leaves that had entranced me since childhood or inspired me on my Asian odysseys. One was the gingko leaf. The gingko is a popular street tree in New York City, where I grew up. From my earliest days, I was fascinated by the leaf's bi-lobal shape, a form in marked contrast to the odd-numbered lobes of the maple and oak leaves with which I was more familiar. The fact that it comes from Japan made it seem all the more exotic, and in time I came to connect its proportions and shape with Japanese aesthetics and the non-duality of existence propounded by many Eastern philosophies, the two halves signifying the true oneness of opposites. Although the leaf itself is primarily symmetric, its pattern of ridges and its crenellated edge can appear quite random. As with the Bodhi Leaf, I proceeded by moving from order to improvisation, introducing a slight asymmetry midway through the folding sequence to conceal a deep crease that would otherwise run right down the center. Additional variation is provided at the end, where the folder generates a series of mountain folds to capture the leaf's organic pattern of veins.

Seeking a completely different type of irregularity to capture, I then set out to model a leaf from the begonia plant. In my travels, I had been struck by the luminous patterns and varied textures of the dozens of species of begonias at Peradeniya Botanical Garden in Sri Lanka. Despite this extraordinary diversity, the underlying form of a begonia leaf remains consistent from species to species. The begonia leaf at first appears so odd and disproportionate that it is hard to locate even the vestiges of symmetry. Further scrutiny, however, reveals the nature

The irregular crenellations of an aged, fan-shaped gingko leaf and the image of a Japanese gingko tree set against a stone wall in Kyoto subtly express both permanence and change. Above, we observe the tree's radiant, golden canopy; below, fallen leaves. Our imagination fills in the gap—we can almost see the wind swirling and the leaves falling. The delicate shadows of the tree and leaves add a further layer of mystery and beauty.

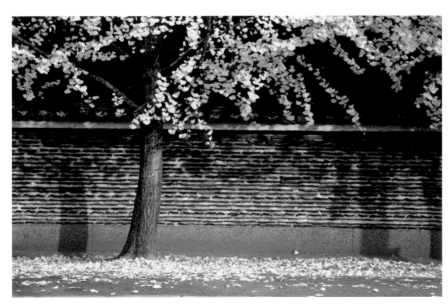

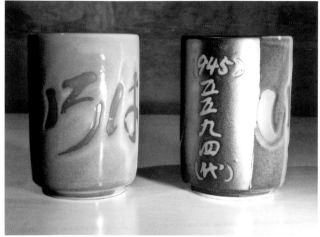

top left: The subtle and irregular coloration of a pair of Japanese teacups given to me by a Tokyo innkeeper evokes their origin in earth and fire.

top right: In a Kyoto garden, an irregular, moss-covered stepping-stone path and fallen leaves speak eloquently of the passage of time.

This wooden window from Tienjin, China is beautiful for its simplicity. It is constructed entirely without screws or nails.

of this order. At the point where the stem joins the leaf, the two lobes are bilaterally symmetric. Similarly, the very tip of the leaf is also bilaterally symmetric. These two axes of symmetry are rotated with respect to each other, often by 45 degrees or more. When I examined the begonia plants at Peradeniya Garden, including tiny leaves just in the process of forming, I found this pattern of broken symmetry repeated over and over. How could it have come into existence?

I concluded that in the original genetic blueprint for the leaf, these two axes aligned, as they do with most leaves. If the two sides were then to grow at different rates, one half of the leaf would rotate relative to the other, and the result would be the shape we see before us. To capture this differential growth in the design of the model, I began with the Maple Leaf, a bilaterally symmetric model I had previously designed, and introduced a rotation midway between the stem and the tip, allowing each to maintain its mirror symmetry while making the leaf as a whole asymmetric. Several weeks after completing my design, I found unexpected support of my intuitive (and botanically ignorant) mathematical theory in the writings of the British mathematician and biologist D'Arcy Thompson, whose work had inspired me years earlier. In Thompson's analysis of bilaterally symmetric leaves, he attributed the variation in their shapes to their differential rates of growth. Presuming a point of no growth at the stem, Thompson drew lines from the stem to the edges of the leaf and analyzed those lines in terms of their radial and tangential rates of growth. If the leaves of three different species of plants have identical tangential velocities but varying radial velocities of growth, the results will be the three divergent shapes shown in his diagram. Extending his analysis to the begonia leaf, Thompson measured lines on both sides of the leaf and showed consistent but different rates of growth for the two sides, corroborating my own conclusions.

A New Direction

As Hannah's birth and the Sun, Moon, and Stars had spoken to me of beginnings, Mark Turner's death and the Bodhi Leaf spoke of endings. The symmetric and regular Sun evokes perfection, a world of idealized forms that exist untouched by time; the asymmetric and irregular leaf, imperfection, a world bound inexorably by birth, growth, aging, and death—and, perhaps, rebirth. With the completion of these models and the Gingko and Begonia leaves, I felt that I had finally begun to

grasp the lessons Yoshizawa had tried to pass along to me many years earlier, back when I was not ready to receive them. In Japanese Buddhism, the phrase *wabi-sabi* captures a belief in impermanence and imperfection, in the beauty of the ordinary, the worn, the used. In India, I had often heard people speak of *sukh* and *dukh*, sweetness and suffering, joy and sorrow. These abstract concepts, deeply rooted in the cultural and religious history of two ancient peoples, now had meaning for me. I had felt them in Japan, coming upon faded, moss-covered funeral statues in the forest near the temples at Nikko, in India hearing the songs of goatherds in the Thar desert. Coming so close upon one another, a birth and a death had revealed to me the inextricable union of *sukh* and *dukh* in our lives.

The Sun, Moon, and Stars and the leaves marked a new phase in my origami design work. By this time, I had a family to support—Hannah was joined four years later by our son, Gabriel—and little time for origami. If I were to get past the technical difficulties in creating an origami design, I would need a greater imperative than had motivated my early models. These new origami works would draw on powerful emotional stimuli and be inspired by craft, music, and the improvisations of nature. The geometric principles that had informed my early work would be a tool, but not a crutch. The resulting models could not be a mere likeness of the original—Debussy's "more or less exact representation of nature"— but would need to delve deeper in order to reveal the subject's essential character, capturing that "mysterious affinity between Nature and the Imagination." And somehow, in some intangible way, they would aspire to express the imperfections of nature and of life: the frail beauty of a world that is always in flux, the transitory and fleeting quality of an existence we can only truly experience when we escape the yoke of our illusions.

I knew that once I set out on this new path, I could not turn back when technical difficulties arose, since it is the surmounting of those challenges that defines the finished creation, giving it its particular form, proportions, and aesthetic. If the

Wicker "doughnut," placed on the head to balance an earthen or metal pitcher, Jaisalmer, Rajasthan, India.

Rug beater, Java, Indonesia is symmetric in silhouette but asymmetric in construction. Its knotted configuration gives it both beauty and strength.

A woven Filipino basket from the Cordillera Mountains beautifully captures the space within.

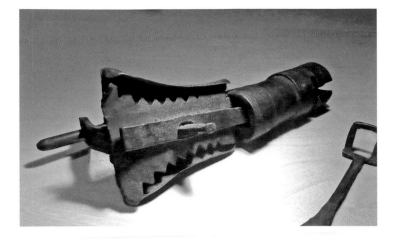

Two clever examples of simple technology are also things of economy and beauty: a forged iron door lock from a house in the Nepalese Himalayas and a glass bottle from Mumbai, India. The irregularity in the form of the lock may be due to the shape of the metal scraps in the ironsmith's shop. The bottle needs no cap. When the bottle is filled with carbonated water or soda, a glass marble sealed inside the neck of the bottle (shown in inset) is pressed against a rubber ring inside the rim by the gas. To break the seal, you pop the marble down into the neck. Two glass protrusions hold the marble in place, allowing the liquid to flow.

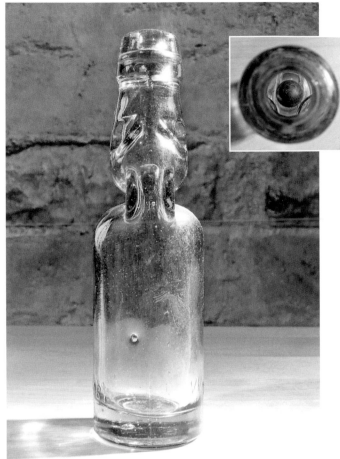

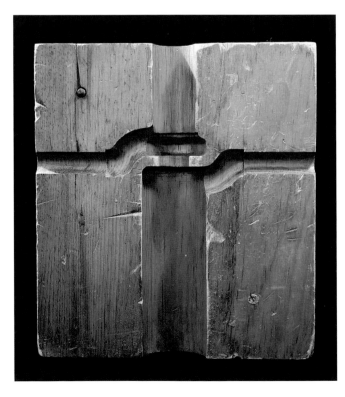

Discovered in a New York City dumpster, this wooden mold for a part to a 1905 steam locomotive evokes time passed. Its void speaks eloquently of silence.

A palm-leaf scoop from West Timor (shown upside-down), and a thatched hat from Sulawesi, both part of Indonesia, use natural materials to practical ends. The scoop, employed by a roving drink vendor in a market, and the conical hat, worn by farmers and fishermen to ward off sun, use folded edges and curvature to achieve structural stability. Both are beautiful and ephemeral.

hole you dig while creating the artwork is too easy to climb out of, then you have not dug deep enough, and the artwork has little to say. If it is too deep to escape, then the technical challenges have defeated you, and there is no finished product.

The models that have tumbled from my hands in the years since—symmetric and asymmetric, animal and human, mythological and real—have tried to be worth the digging. The birth of Gabriel inspired a mobile of the Seagull and Whales. Years later, I devised, for Gabriel, the Sea Serpent; for Hannah, the Forest Troll; and for Cheryl, the Orchid and Waves. The simpler models I invented for my second book, *10-Fold Origami*, brought back the enchantment I had felt on first discovering origami as a child: a Rocket Ship, a Spinner, a Snail on a Leaf, a Hatching Chick (the white egg splits open to reveal a yellow chick), a Snake with a zig-zagging stripe. *10-Fold Origami* also serves up a Breakfast Special featuring a folded Sunny Side Up, while this book's Inflatable Egg provides its missing third dimension.

Each of the animals that inspired a design in this book has also touched me in some profound and inexplicable way. These animal models aim to capture the essential gesture of their subject, and something of the mythic quality that human beings have bestowed upon them: the hovering and menacing Bat; the compact and poised Squirrel, with its billowing tail and white teeth, revealing its inner rodent; the fluid Sea Turtle; the motionless Owl, possessing the immobility of a sentry; and the undulating Stingray, for whom movement is life. If I have succeeded with these designs, it is not because I have replicated the original, but rather made a symbol of a symbol.

Like any transforming work of art, an origami model reflects back on the life and forms that inspired it. If it reopens our eyes to the virtuosity of nature, if it helps us see anew the original animals, leaves, waves, or creatures of the human imagination, the artist has succeeded in his quest. As Yoshizawa might have put it, these origami figures have sought, and received, a form in which to express their powerful spirit. Tenuously present in our material world, they yield flickering glimpses of a world that might otherwise pass unseen.

FORM

THE ORIGAMI ART OF PETER ENGEL

PATTERN

The transformation from
inanimate square into living,
breathing creation takes place
through sheer **imagination**.
It is a kind of magic. The
constraints of the medium
stimulate, rather than limit,
the folder's creativity.

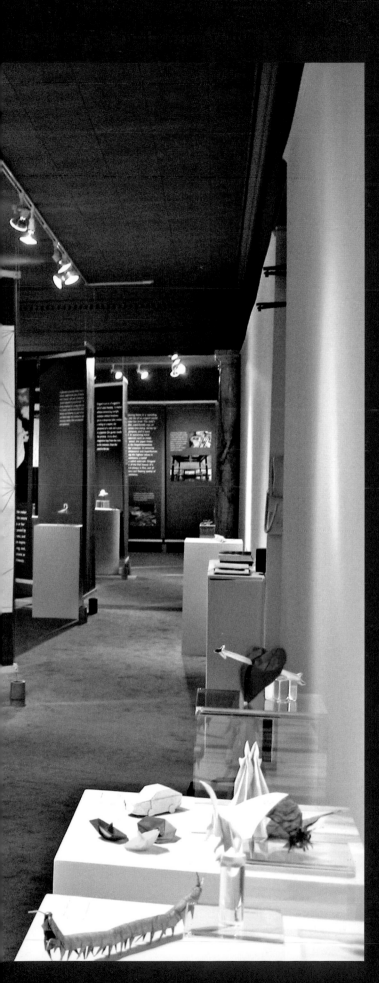

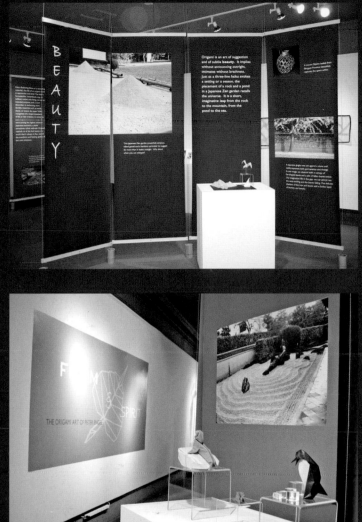

A retrospective of my origami work at Gettysburg College in Pennsylvania was the genesis of this essay. For the exhibit, Mao Tseng and I designed and constructed hanging banners from paper, bamboo, and steel cable in the style of modernized Japanese scroll paintings and screens.

Origami Projects

Symbols and Basic Folds

Origami diagrams are like a composer's score or an architect's plans: They are the key to interpreting the design, the means by which the performer or builder realizes the creator's intentions. Learning to read folding instructions takes practice, just like learning to follow a musical score. The basic folding procedures and symbols used in these diagrams follow an internationally accepted standard. When you have mastered the ones here, you should be able to follow the instructions in virtually any origami book.

Symbols

Symbols consist of two types: arrows and lines. There are many types of arrows, whose expressive shapes suggest the motion of the paper.

A couple of arrows have specific meanings. The top arrow means "turn the paper over." The bottom arrow, with two heads, means "fold and unfold."

There are six types of lines used in this book:

A *thick* line shows the outline of the diagram against the page.

A *medium* line represents an edge of the paper, either the original edge or one produced by folding.

A *thin* line represents a crease in the paper that was formed in an earlier step.

A *dashed* line represents a valley-fold.

A *dotted and dashed* line represents a mountain-fold.

A *dotted* line represents a fold hidden from view, or occasionally a fold about to be formed.

Basic Folds

A piece of paper has two sides. Thus, it can be folded in either of two directions. Each of these folds has a name: *valley-fold* and *mountain-fold*. Every origami folding procedure is a valley-fold, a mountain-fold, or a combination of valley- and mountain-folds.

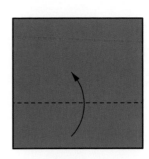

Forming a valley-fold:

Swing the lower edge upward to produce a valley-fold. If you swing the lower edge back down, a thin line indicates where the paper has been creased.

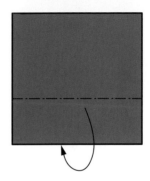

Forming a mountain-fold:

Swing the lower edge underneath to produce a mountain-fold. If you swing the lower edge back up, a thin line indicates where the paper has been creased.

A *reverse-fold* combines valley-folds and mountain-folds. In a reverse-fold, two or more layers of paper are folded together symmetrically along a single crease. The reverse-fold comes in two types: *inside reverse-fold* (the more common) and *outside reverse-fold*.

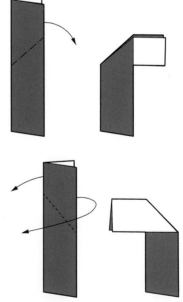

Forming an inside reverse-fold:

Crease firmly with either a mountain- or a valley-fold to form the line of the reverse-fold. Spread the open edges of the paper and turn the top portion inside-out. Flatten to form an inside-reverse fold.

Forming an outside reverse-fold:

Crease firmly with either a mountain- or a valley-fold to form the line of the reverse-fold. Spread the open edges of the paper and turn the top portion outside-in. Flatten to form an outside reverse-fold.

In a *crimp-fold,* a pair of valley-folds and mountain-folds converges at one point. The creases on the front and rear layers are mirror images of each other.

Forming a crimp-fold:

Valley-fold and mountain-fold the front and back. Flatten to form a crimp-fold.

In a *pleat-fold,* a mountain- and a valley-fold are parallel, or nearly so. A pleat can be performed on any number of layers. They are folded together as one.

Forming a pleat-fold:

Valley-fold and mountain-fold the front and back. Flatten to form a pleat-fold.

In a *rabbit's ear fold,* the three angles of a triangular flap are bisected (divided in two) by valley-folds. Often the angle that protrudes from the plane of the paper is swung to one side or another, producing a small mountain-fold. The triangle can be any shape, and in some rabbit's-ear folds, the angles are divided unevenly.

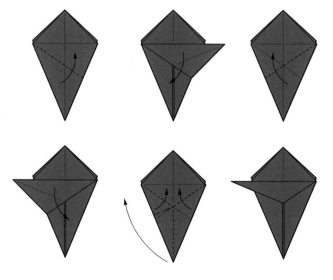

Forming a rabbit's ear fold:

Valley-fold the outer edge of the loose flap up to meet the horizontal crease. Unfold. Repeat on the opposite side. Unfold. Perform both valley-folds simultaneously and swing the tip of the loose flap to one side, forming a small mountain-fold. Flatten to complete the rabbit's ear fold.

One other procedure merits special attention. A *sink-fold* is a kind of three-dimensional reverse-fold. In a sink-fold, a portion of the paper that is convex (projecting out) is reversed into the paper to become concave (projecting in), and may even be reversed back out again, as desired. The sink-fold comes in two basic forms. In an *open sink,* the paper that is being sunk passes through a phase of being completely flat. This operation is indicated by a hollow arrow. In a *closed sink,* the sunk portion "pops" from its convex position to its concave position without ever becoming flat. This operation is indicated by a solid arrow.

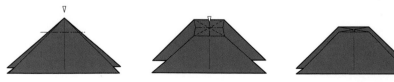

Forming an open sink-fold:

Crease firmly with either a mountain- or a valley-fold to form the line of the sink-fold. Spread the center of the paper and push the upper portion downward. The upper portion of the paper will flatten and then turn inside-out. Flatten to complete the open sink-fold.

Forming a closed sink-fold:

Crease firmly with either a mountain- or a valley-fold to form the line of the sink-fold. Spread the center of the paper and push the upper portion downward. The upper portion of the paper will not flatten but will "pop" inside-out. Flatten to complete the closed sink-fold.

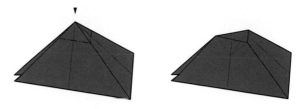

Paying attention to a few folding tips will improve your results:

- Study each diagram carefully and read the accompanying text before commencing a fold. Look ahead to the next diagram to examine the result.

- Make creases crisp. A sloppy fold made early on will grow even sloppier over the course of folding.

- Remember that paper has a thickness. Layers of paper accumulate and in more complicated models may reach an eighth of an inch. It is often best to leave space between two adjacent edges so that in subsequent folds they will not overlap and bunch.

- Be patient. A careless maneuver in the late stage of a model can rip the paper and mar the result. If a model proves too complicated, try another, and then return to the first. The initial attempt at folding a model rarely yields a masterpiece, but repeated tries will eventually produce a model of which you can be proud.

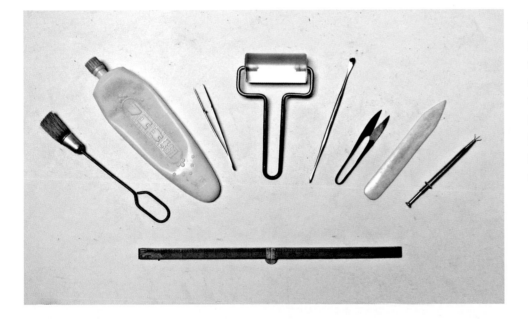

Tools of the trade: The paperfolder's tools can be as simple as ten trustworthy fingers or as individualized as my own set of tools, shown here. Two of the more unusual are a bone burnisher (*second from right*), used for creasing, and a Japanese pearl holder (*far right*), used to grip and manipulate tiny flaps of paper.

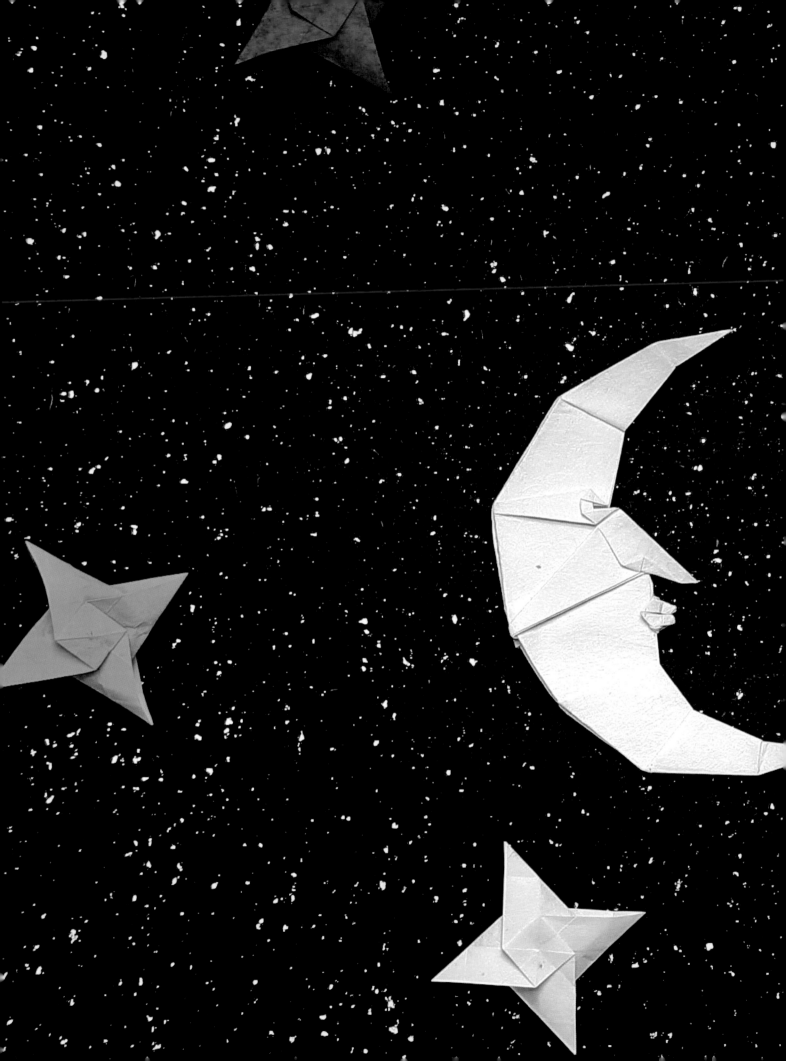

The Solar System

Sun

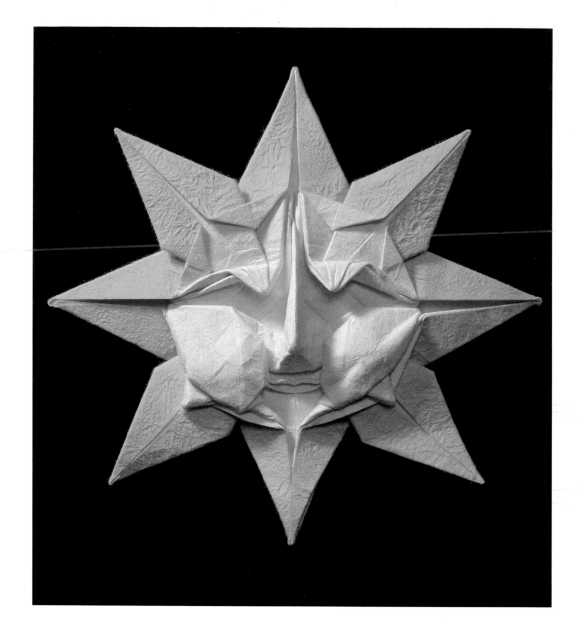

A 10-inch (25-cm) square produces a
sun 7 1/4 inches (18 cm) from tip to
tip.

1 Use strong paper at least 10 inches
square, and preferably larger for your first
attempt. Valley-fold diagonals and unfold.
Turn over.

2 Valley-fold edge to edge and unfold.

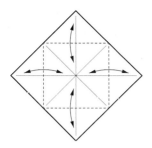 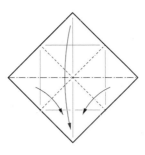 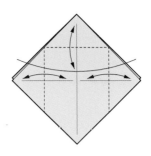

3 Valley-fold corners to center and unfold.

4 Swing three corners down along existing creases to meet bottom corner. This procedure is called a preliminary fold.

5 Diagram enlarged. Valley-fold three corners to the center, creasing all thicknesses, and unfold. The curve shows the detail in the next step.

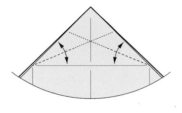 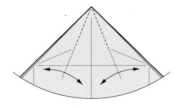 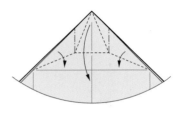

6 Valley-fold from edges to horizontal crease and unfold. Crease only where valley-fold is shown.

7 Valley-fold from edges to centerline and unfold. Crease only where valley-fold is shown.

8 Swing down tip on valley-folds just formed, creating new mountain-folds in the process.

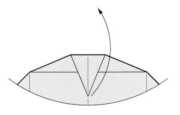 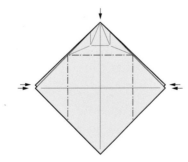 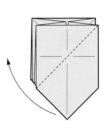

9 Unfold tip.

10 Reverse-fold top and sides on existing creases.

11 Swing front flap up and to the left.

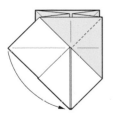 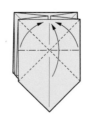

12 Unfold. Repeat Step 11 and this step on right-hand side.

13 Swing entire flap up on existing creases.

14 Repeat Steps 11 to 13 on sides and rear.

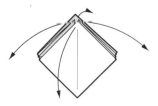

15 Unfold four corners and flatten.

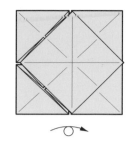

16 Turn over.

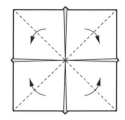

17 Valley-fold white flaps.

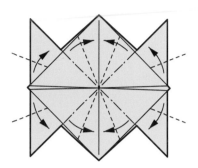

18 The mountain-folds lie on existing creases. Pivot them to fall on the center-line. The rotation of the paper causes new valley-folds to form along the sides, exposing the white side of the paper.

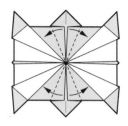

19 Pivot each flap away from the center-line to where it falls naturally.

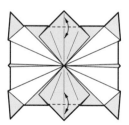

20 Valley-fold each tip and unfold. Undo previous folds and return to position in Step 18.

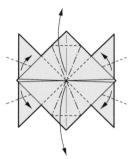

21 Lift single ply at the midpoint of the long edge of each large triangle, stretch, and allow paper to collapse on existing creases.

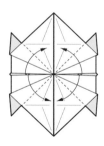

22 Pivot multiple plies of paper toward the centerline.

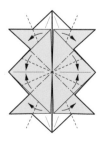

23 Repeat Steps 18 to 21 on left- and right-hand flaps.

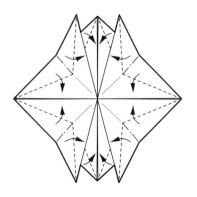

24 The diagram shows four white flaps protruding from the rest of the paper. Narrow all eight white flaps with valley-folds. The model will not lie flat.

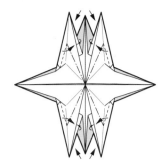 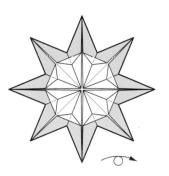 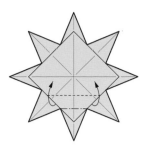

25 Continue to narrow the four protruding flaps while pressing straight down on the centerline of each flap. Carefully squash the sides of each flap to allow the four protruding flaps to lie flat.

26 The model is now flat. Turn over.

27 Place thumbs below one ply of paper on either side of the bottom point of the square. Lift upward and spread the paper below the mountain-fold. The valley-fold forms automatically.

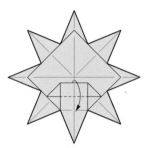 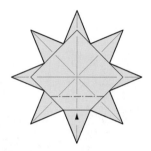 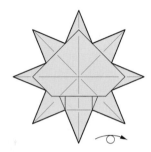

28 Swing upper flap down.

29 Carefully closed-sink through existing crease.

30 Turn over.

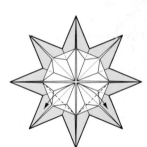 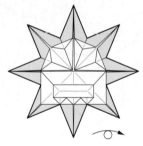 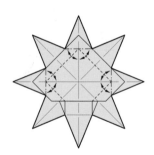

31 Swing each white flap as far as it will go. Hidden paper will stretch. Smooth it evenly and flatten.

32 Turn over.

33 Fold edges of square toward center and unfold. Make sure valley-folds meet crisply at corners.

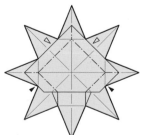

34 Closed-sink bottom two edges of central "square" (with flattened bottom) and open-sink upper two edges of square. The central square, with the exception of the bottom horizontal edge, becomes elevated from the rest of the model. The model becomes 3-D.

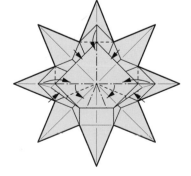

35 This is a complex and challenging 3-D maneuver. Study the creases radiating from the center. Push in at all four straight arrows to puff up the central square. The horizontal mountain-folds rotate down and swing over the valley-folds. The central mountain-fold becomes the front edge of the nose, and the isosceles triangle below it the base of the nose. The flaps at the far left and right sides will flatten, while the nose flap and the isosceles triangle below it will project from the paper.

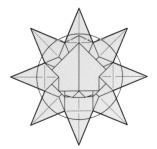

36 The front edge of the nose is seen head-on as a single line. The circle shows the detail in the next step.

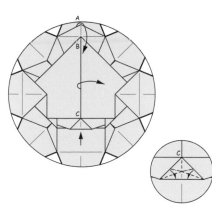

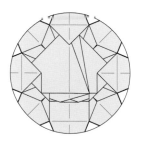

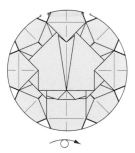

37 Swing nose flap to the right while collapsing the little isosceles triangle as shown in the inset. Note locations of points A, B, and C.

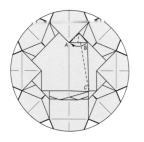

38 The model is now flat. Valley-fold from intersection to intersection. Tuck loose paper underneath at A.

39 Unfold creases made in Step 38 and refold symmetrically. The model will not lie flat.

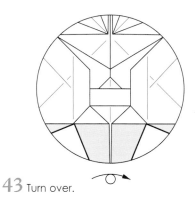

40 The nose is seen head-on, with the front edge turned into a flat plane. (See Step 44 for a 3-D image.) Turn model over but do not flatten.

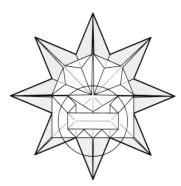

41 Circle shows area of detail in next step.

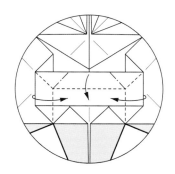

42 The white rectangle will become the lips. Valley-fold the top half down and simultaneously swing in the sides.

43 Turn over.

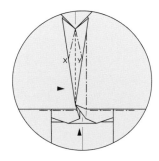

44 Another difficult 3-D maneuver. Carefully closed-sink both the bottom and front of the nose through the paper and out the other side. The procedure is symmetric. The vertical mountain-fold meets an angled valley-fold not shown in the diagram (it is obscured by the front of the nose-flap). The nose turns inside-out and two angled mountain-folds form, terminating at X and Y. Note positions of X and Y in the next diagram and look ahead to Step 46 to see the formation of the nose on the other side.

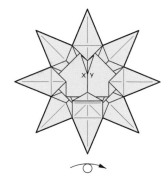

45 The nose now projects from the other side. Turn over.

46 The model is symmetric, but the nose is shown angled to the right. The lower circle shows the details in Steps 47 through 49. The upper circle shows the details in Steps 50 and 51.

47 Valley-fold bottom half of lips upward, including the small, hidden portions at the sides. The white triangle at the lower right will become a tiny flame. Perform the folds in Steps 6 through 8 on this triangle.

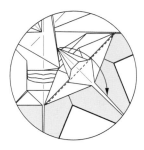

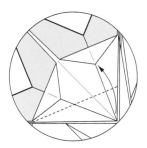

48 Shape the lips. Valley-fold the small triangle so the flame becomes as long as possible. The paper beneath stretches and the edges align.

49 Lips completed. Swing the flame assembly down and to the right. See the final diagram for the result. Repeat the procedures in Steps 47, 48, and this step to create the flame on the left-hand side of the model.

50 Valley-fold the lower right-hand corner of the white flap so it touches the upper intersection. The left-hand end of the valley-fold will not touch the intersection on its side.

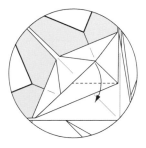

51 Valley-fold horizontally to produce an eye. Repeat Step 50 and this step on the right side.

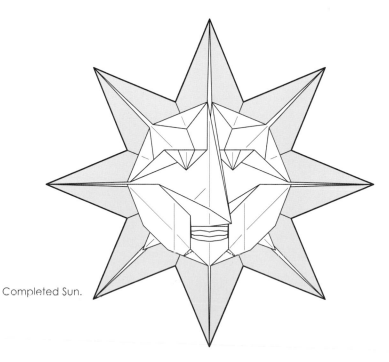

Completed Sun.

Moon

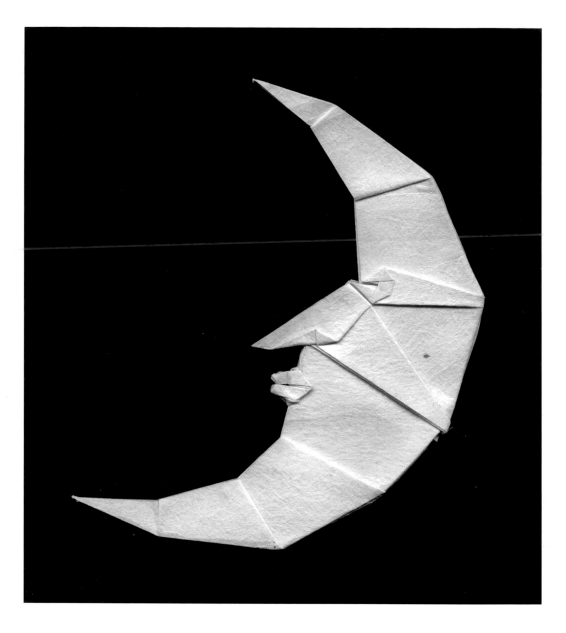

A 10-inch (25-cm) square produces a moon 7 ¹/₄ inches (18 cm) tall.

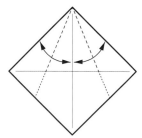

1 Begin with the paper creased along the diagonals. Valley-fold upper edges to centerline and unfold.

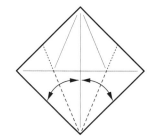

2 Valley-fold bottom edges to centerline and unfold.

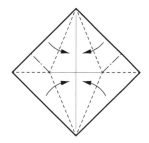

3 Collapse all four sides at once. The mountain-folds form in the process. The result is called the fish base.

4 Swing the left side behind.

5 Valley-fold upper edge of small triangle to horizontal crease.

6 Enlargement. Crimp to form nose.

7 Valley-fold to form nostril.

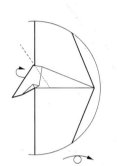

8 Valley-fold hidden paper to lock. Turn over.

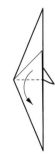

9 Swing down triangular flap.

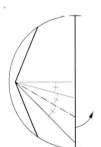

10 Inside reverse-fold through one-third of angle.

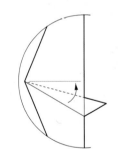

11 Swing up front flap.

12 Mountain-fold tip.

13 Form tiny reverse-folds.

14 Narrow symmetrically and pinch little triangles at right to form the lips.

15 Open-sink to narrow lips.

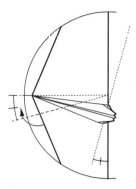 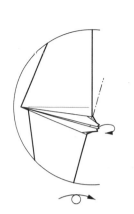 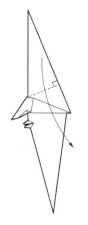 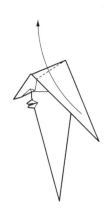

16 Note the angle shown at lower right between the vertical edge of the paper and the line connecting the top and bottom of the lips. Crimp the entire model symmetrically to form the same angle. See next diagram for result.

17 The hidden rear of the lips can now be mountain-folded behind on a line extending directly from the edge of the paper. Turn over.

18 Valley-fold upper triangular flap at the bridge of the nose so the right-hand edges align.

19 Valley-fold flap back up. Note location of left-hand side of valley-fold.

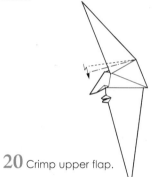 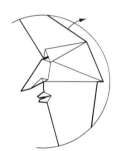 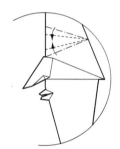 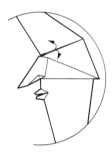

20 Crimp upper flap.

21 Unfold flap to position in Step 18.

22 Refold along existing creases so they land symmetrically front and rear.

23 Pull out loose paper from pocket and reform along existing creases. Repeat behind.

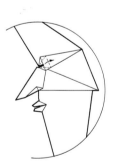 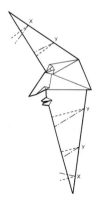 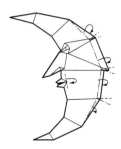 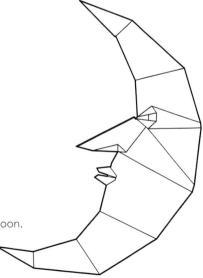

24 Stretch edge of paper to the right and fold in sides to form eye. Repeat behind.

25 Form five pairs of crimps, each of them symmetric. All of the valley-folds are perpendicular to the left-hand edge. Crimps marked X are "inside" crimps, those marked Y "outside" crimps.

26 Narrow right edge, front and back, with mountain-folds. Mountain-fold rear tip of lips.

Completed Moon.

Stars

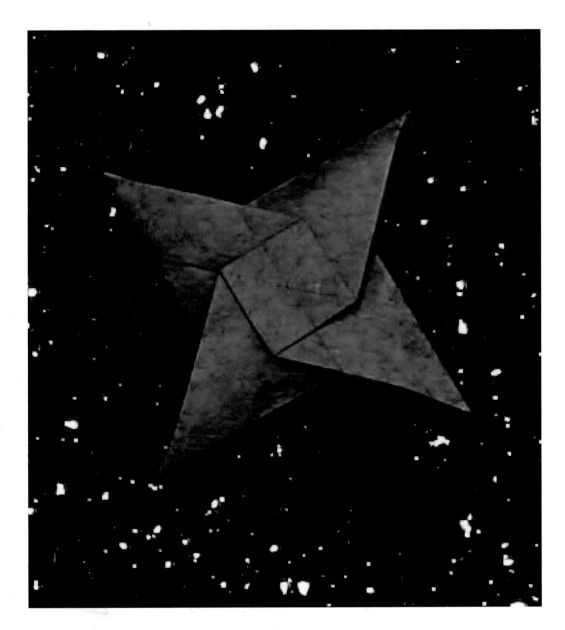

A 10-inch (25-cm) square produces a star 6 $\frac{1}{4}$ inches (16 cm) from tip to opposite tip.

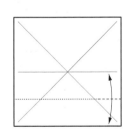

1 Begin with the paper creased horizontally and along the diagonal. Lightly valley-fold bottom edge to horizontal line, pinching at right-hand edge, and unfold.

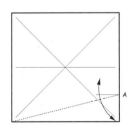

2 Lightly valley-fold to pinch mark (called A), pinch at diagonal, and unfold.

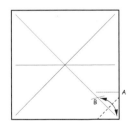

3 Lightly valley-fold corner to pinch mark formed in previous step (called B), and unfold.

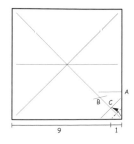

4 Firmly valley-fold corner to intersection formed in previous step (called C).

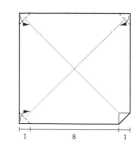

5 Using guidelines of your choice, fold three other corners equally.

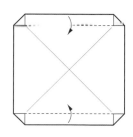

6 Valley-fold at top and bottom.

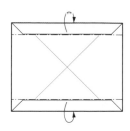

7 Mountain-fold at colored edges.

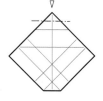

8 Unfold to position in Step 5.

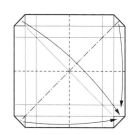

9 Fold along existing vertical, horizontal, and diagonal creases to collapse paper.

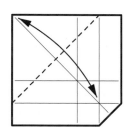

10 Valley-fold upper left-hand corner (the center of the paper) to indicated intersection, and unfold. Rotate model clockwise so center of the paper is at top.

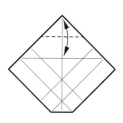

11 Valley-fold tip to indicated intersection and unfold.

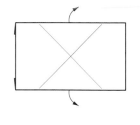

12 Open-sink tip to crease just formed. Valley-fold before sinking.

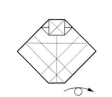

13 Spread the paper at the tip and squash.

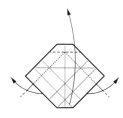

14 Turn over.

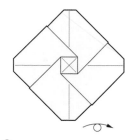

15 Spread the four corners and squash.

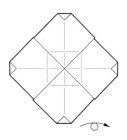

16 Turn over.

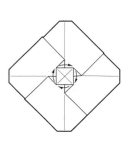

17 Swing two flaps clockwise.

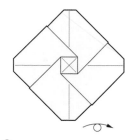

18 Rotate four flaps at center clockwise.

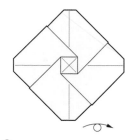

19 Turn over.

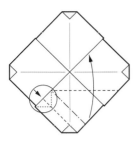

20 Follow existing creases as much as possible. Paper stretches at circled area and hidden creases form.

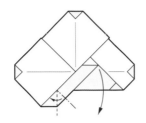

21 Swing large flap down and simultaneously swivel small flap clockwise.

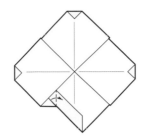

22 Valley-fold. Repeat Steps 20, 21, and this step on three other sides.

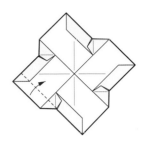

23 Valley-fold.

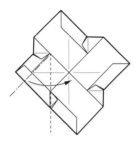

24 Swing flap to the right but do not completely flatten.

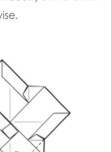

25 Repeat Steps 23 and 24 on three other sides. Interlock all four flaps at the center.

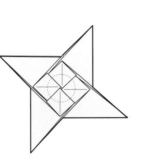

26 If you will be hanging the star from a wire, fashion one end of the wire into a circle, loosen the flaps at center, and insert circular end of wire, allowing the straight portion to protrude.

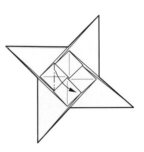

27 Squash one square flap to produce a triangle.

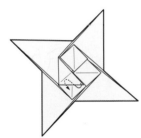

28 Tuck half of triangle into adjoining square.

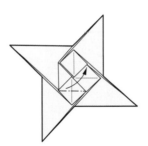

29 Repeat on three other sides, tucking the last triangle into the first to lock.

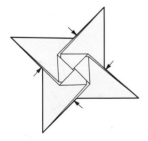

30 Insert finger into cavities to puff out star. If a wire is inserted as in Step 26, the star will spin as the wind blows.

Completed Stars.

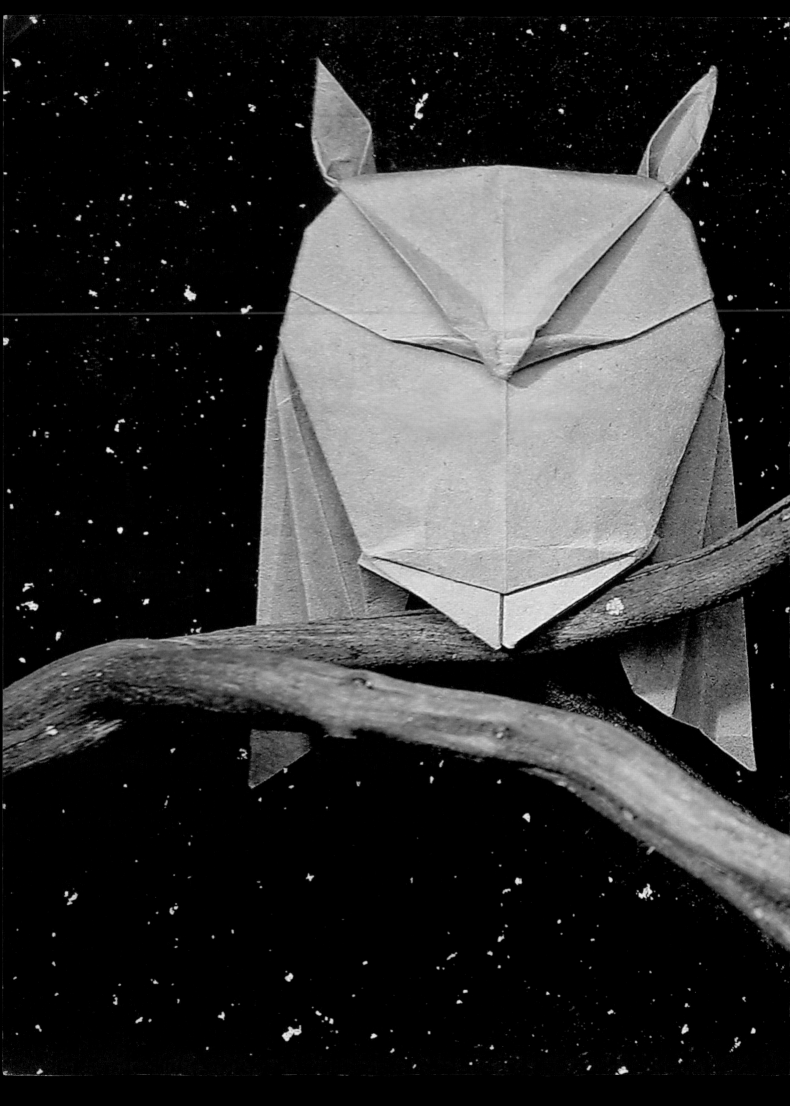

CHAPTER 2

In the Forest

Squirrel

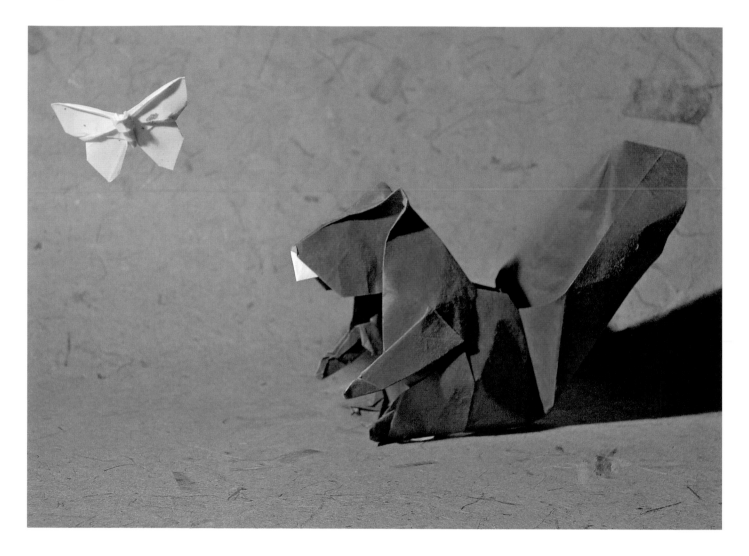

A 10-inch (25-cm) square produces a squirrel 6 ¹/₄ inches (16 cm) from nose to tail.

1 Begin with paper creased vertically. Valley-fold edges to centerline and unfold. Turn over.

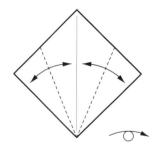

2 Valley-fold where existing crease meets edge and swing tip to right.

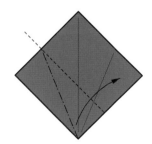

3 Unfold and repeat previous step on opposite side.

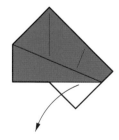

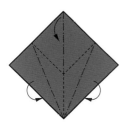 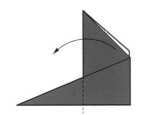 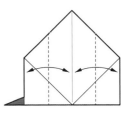

4 Swing sides behind and top forward, all along existing creases.

5 Swing front flap to left.

6 Valley-fold edges to centerline and unfold.

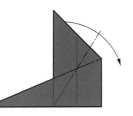 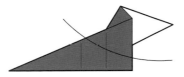 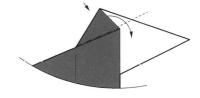

7 Reverse-fold upper flap. Fold begins at bottom and passes through intersection.

8 Curve indicates enlargement in next step.

9 Reverse-fold along existing crease at rear and edge at front. See next diagram for result.

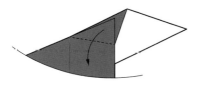 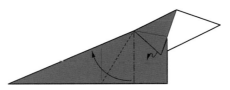 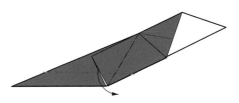

10 Note that the two top edges do not align. Swing flap down and to the left as far as it will go.

11 The vertical creases are existing. Pull out loose paper and swing up and to the left, forming a new valley-fold. See next diagram for result.

12 Note again that two top edges do not align. Reverse-fold.

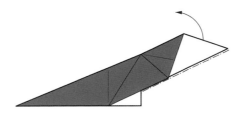 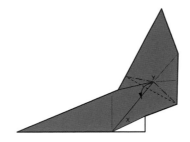 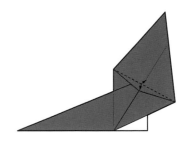

13 Swing white flap symmetrically through the center of the model as far as it will go. The paper will not lie flat. The next diagram shows the paper extended in 3-D.

14 Pinch paper at X on front and back and slowly flatten model. Points Y on front and back will swing down.

15 Model is now flat. Swing the thin flap up and to the right and unfold.

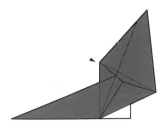 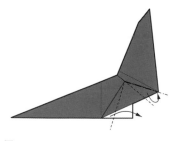 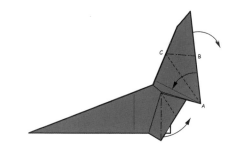

16 Carefully closed-sink the central flap as far as it will go, from base to intersection with edge at middle of model. Location of fold at top occurs automatically.

17 Swivel and tuck a portion of paper under the arm (right side of diagram) as far as it will go. This will free up paper at the bottom, allowing it to swivel to the right. Crease forms automatically. Repeat behind.

18 Bottom of diagram: Pinch at existing crease passing through corner and pivot to the right as far as it will go. Repeat behind. Top of diagram: This procedure is symmetric. Valley-fold so that edge AB lands on existing crease line at tip of arrow. Point C forms where the fold meets the left-hand edge. In the process, form a mountain-fold at CB and rotate top of model to the right. Note that paper at C will bunch.

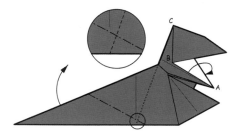 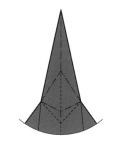 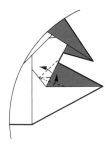 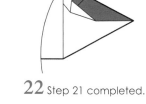

19 Inside reverse-fold tail up and to the right. Note that the mountain-fold extends past hidden interior intersection. See detail for enlargement. Spread paper symmetrically at the center to permit a clean fold.

20 View from back of head looking at centerline of model. Disentangle paper bunched in Step 18 and collapse symmetrically along existing creases. This process frees up paper for the ears formed in Step 24.

21 Detail showing inside of model. Stretch white paper to the left to round belly. Repeat on opposite side.

22 Step 21 completed.

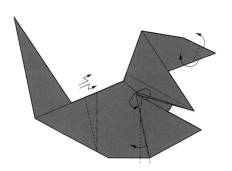 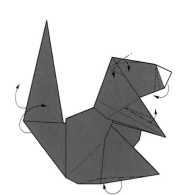 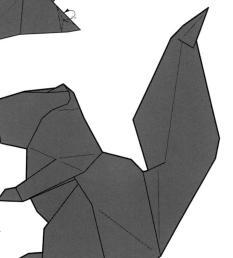

25 Crimp top of tail. Round back with mountain-folds. Crimp hind and front legs to form feet.

23 Crimp tail symmetrically, pushing paper inside model to one side. Crimp at bottom of diagram on front and back of model, causing model to become 3-D. Round hip with a mountain-fold and repeat behind. Outside reverse-fold tip of head; crease is perpendicular to the top of edge.

24 Spread tail and make 3-D. Shape bottom of hind legs. Crimp front legs. Shape ears. Crimp front of head to allow teeth to project.

Completed Squirrel.

Bat

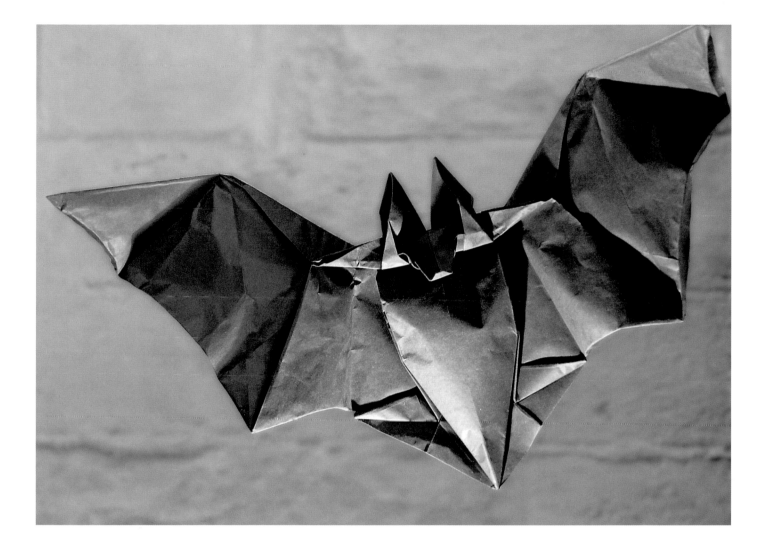

A 10-inch (25-cm) square produces a bat with a 7 1/2 -inch (19-cm) wingspan and a body 3 3/4 inches (9 cm) from tip of ears to tail.

1 Valley-fold diagonals and unfold.

2 Valley-fold corners to center and unfold.

3 Valley-fold in half.

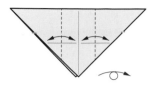

4 Note intersection of horizontal crease and edge of paper. Valley-fold from that intersection to centerline on left and right sides.

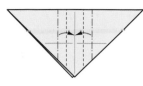

5 Mountain-fold along creases formed in previous step and pleat to centerline, forming new valley-folds.

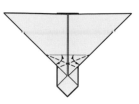

6 Bisect angles across centerline with valley-folds, and unfold.

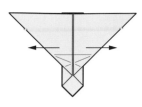

7 Unfold to Step 5.

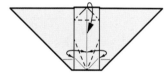

8 Mountain-fold front and back at intersections.

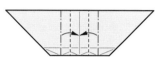

9 Refold on existing creases.

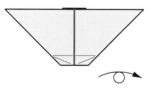

10 Turn over.

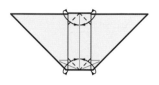

11 Valley-fold top and bottom edges to centerline and unfold.

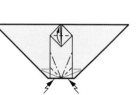

12 Top: Mountain-fold on creases formed in previous step and swing down, forming a horizontal valley-fold. Bottom: Valley-fold creases formed in previous step to centerline and unfold.

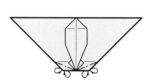

13 Top: Valley-fold small triangle upwards. Bottom: Crimp multiple thicknesses along creases formed in previous steps.

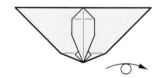

14 Mountain-fold front flaps and valley-fold rear flaps on existing creases.

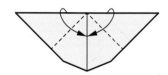

15 Turn over.

16 Valley-fold.

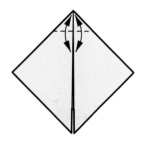

17 Valley-fold where creases fall naturally and unfold.

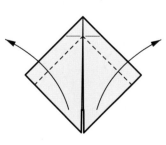

18 Creases are parallel to top edges and meet at horizontal crease.

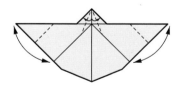

19 Valley-fold tips to crease intersections and unfold. Valley-fold edge to edge at top.

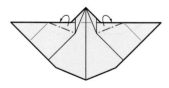

20 Mountain-fold to where creases touch upper edge and stretch loose paper.

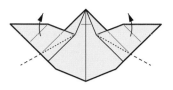

21 Swivel wings as far as they will go along hidden creases.

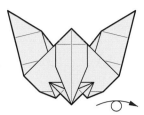

22 Reverse-fold tips and turn over.

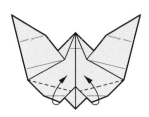

23 Step 22 completed. Turn over.

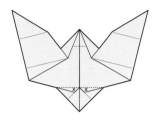

24 Valley-fold as far as paper will stretch.

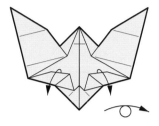

25 Unfold and turn over.

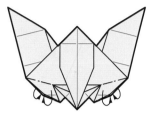

26 Mountain-fold front flaps and valley-fold rear flaps on existing creases.

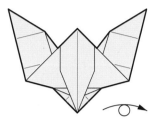

27 Step 26 completed. Turn over.

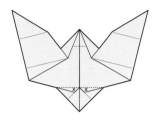

28 Tuck flaps marked X into pockets below.

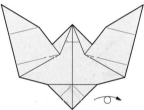

29 Turn over.

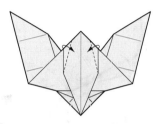

30 Valley-fold sides of body but leave space between tips. See next diagram for location.

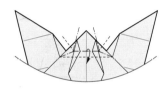

31 This is a form of rabbit's ear. Crimp top downward and tuck sides behind.

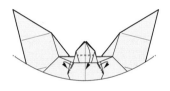

32 Narrow body along existing edges. Swing down front ply between the flaps on either side of it to form the face.

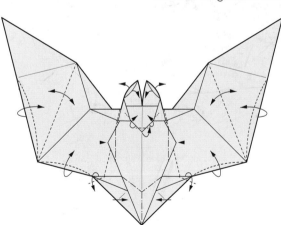

33 Head: Fold up tip to form nose. Twist sides of face with tweezers to form eyes. Round ears and rotate forward. Body: Closed-sink both sides. Stick fingers into pocket in back to puff out belly. Pinch bottom of body to form tail. Outside-reverse-fold tips of legs to form feet. Wings: Form new valley-folds as shown from point to point and curve edges.

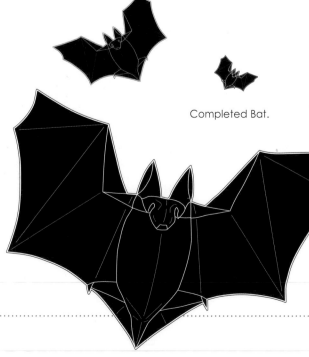

Completed Bat.

Great Horned Owl

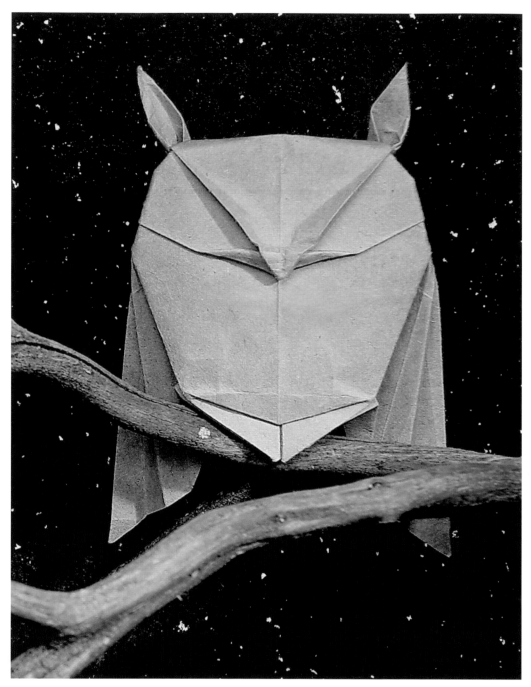

A 10-inch (25-cm) square produces an owl 6 ³/₄ inches (17 cm) from tip of "horns" to bottom of wings.

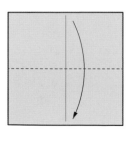

1 Begin with the paper folded in half vertically. Valley-fold downward.

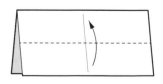

2 Valley-fold one ply to upper edge.

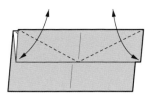 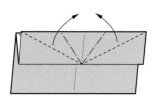 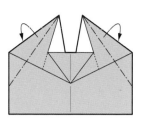 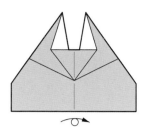

3 Valley-fold from center to corners and unfold.

4 Swing corners upwards while reforming valley-folds. The mountain-folds form automatically.

5 Align edges of square with edges of white flaps. Valley-fold lightly before mountain-folding in order to locate creases.

6 Turn over.

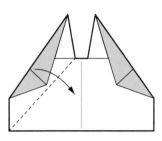 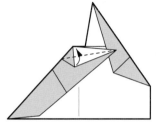 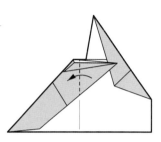

7 Valley-fold passes from lower left corner to intersection of edges. Lower left-hand edge does not quite meet bottom edge.

8 Valley-fold from tip to tip. Lower edge does not quite meet upper edge.

9 Valley-fold directly over centerline.

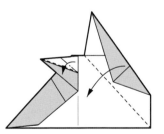 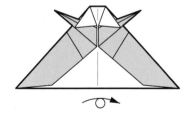 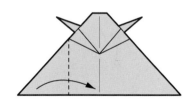

10 Roll paper over so white edge matches colored edge beneath. Repeat 7 through 9 and this step on right-hand side.

11 Turn over.

12 Valley-fold vertically where creases meet.

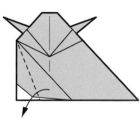 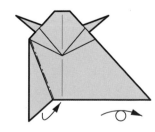 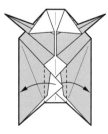

13 Valley-fold edge to edge.

14 Swing hidden flap behind on existing crease. Repeat 12 through 13 and this step on right-hand side. Turn over

15 Valley-fold each flap vertically as far as the paper will go.

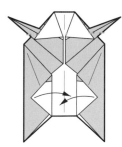

16 Unfold.

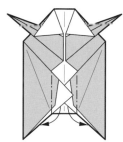

17 Reverse-fold along the creases just made.

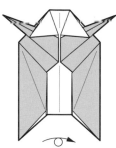

18 Turn over.

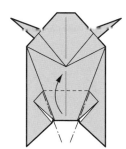

19 Valley-fold directly upward. Side flaps swing in automatically.

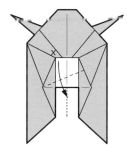

20 Valley-fold so that X falls on center-line.

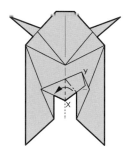

21 Valley-fold along centerline and swing paper to left, forming an angled valley-fold that is the mirror image of the crease made in the previous step.

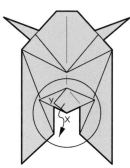

22 Unfold. Circle shows area of detail in next few steps.

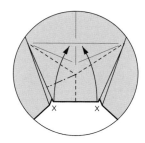

23 Swing flap upward, forming new creases to create a rabbit's ear. Two points marked X meet.

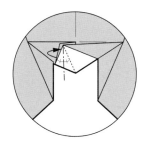

24 Reverse-fold white tip so edge falls along dotted line.

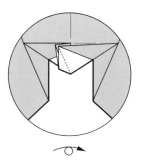

25 Turn over.

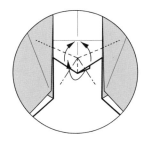

26 Swing entire assembly up along existing valley-folds.

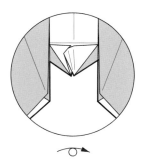

27 Allow the little central triangle, which is shown folded to the left, to stand up vertically. Turn over.

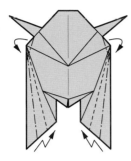 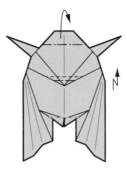 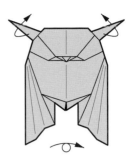

28 Pleat wings into thirds, folding the two thicknesses together. While the paper is stacked in thirds, narrow head with tiny mountain-folds to lock pleats at top. Bottom of pleats will release automatically to form a fan shape.

29 Mountain-fold top of head just above "horns," which are really feathery tufts. Mountain- and valley-fold head to produce beak.

30 Swivel "horns" behind as far as they will go—no new creases. Turn over.

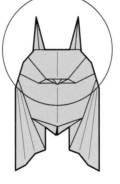

32 Circle shows area of detail in next step.

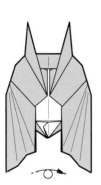

31 View of the back. Turn over.

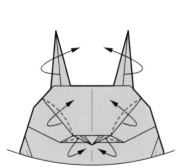

33 Narrow beak by swiveling loose paper beneath. Round eye-sockets. Open out "horns."

Completed Great Horned Owl.

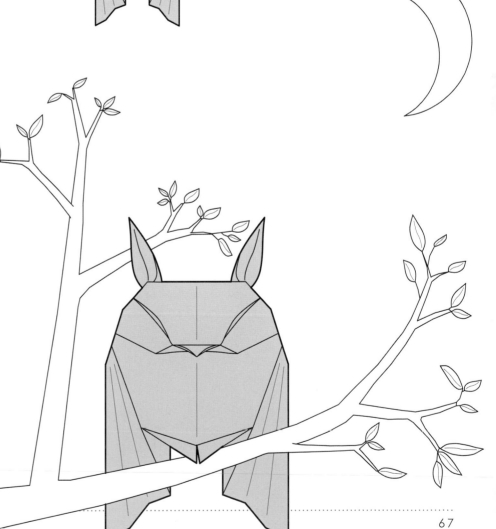

In the Garden

Maple Leaf

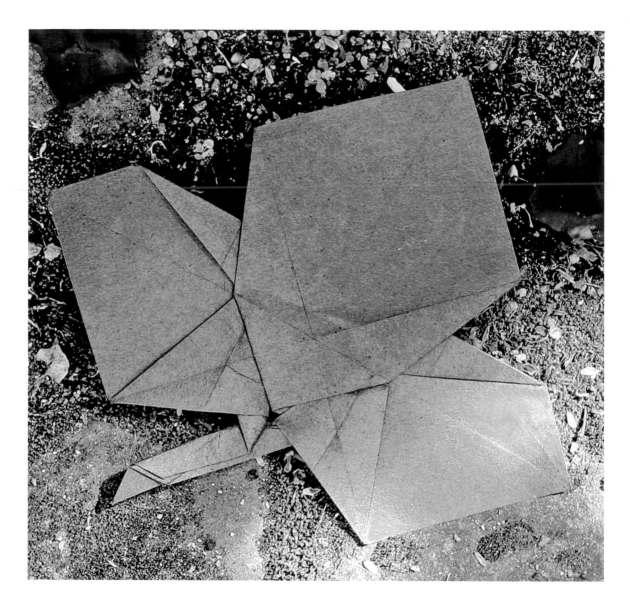

A 6-inch (15-cm) square produces a leaf 5 ³/₄ inches (14 cm) wide.

1 Crease and unfold.

2 Crease and unfold.

3 Lightly fold edge to diagonal and pinch where fold crosses horizontal crease.

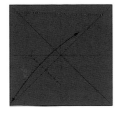 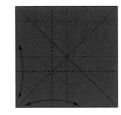 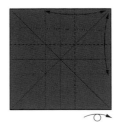 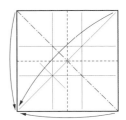

4 Crease at pinch mark and unfold.

5 Crease at intersection formed in previous step and unfold.

6 Crease at intersections formed in previous step and unfold. Turn over.

7 Collapse along existing mountain- and valley-folds. Rotate 45 degrees.

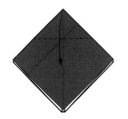 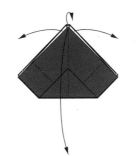 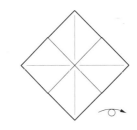 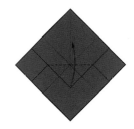

8 Valley-fold tip at intersection of creases and rotate 180 degrees.

9 Keeping the lower triangle folded flat against the adjacent paper, spread and squash the four corners along existing creases.

10 Turn over.

11 Swing triangle up as far as it will go.

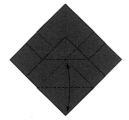 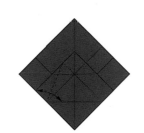 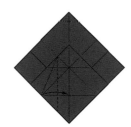 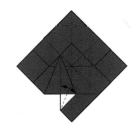

12 Crease lightly and unfold.

13 Valley-fold from intersection to intersection. The lower left-hand edge becomes horizontal. Unfold.

14 Squash along the crease just made. The vertical valley-fold forms naturally.

15 Valley-fold edge to edge and unfold.

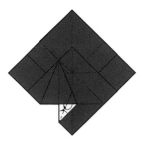 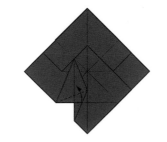 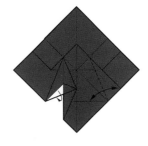

16 Repeat valley-fold, but reverse-fold the upper portion.

17 Valley-fold to where the crease falls naturally.

18 Swing the white flap inside. Repeat Steps 13 through 17 and this step on the right-hand side.

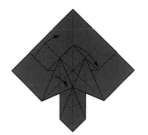

19 Swing the central flap down and to the right. All three folds are done simultaneously.

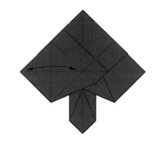

20 Repeat Steps 12 through 18 on the left-hand flap. Note that this flap is rotated 90 degrees relative to the flap in Step 12.

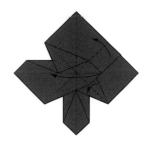

21 Swing the central flap to the left. All three folds are done simultaneously.

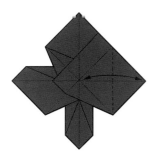

22 Repeat Steps 12 through 18 on the right-hand flap.

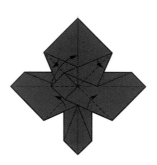

23 Valley-fold the four side flaps and swing the central flap up. This will make the model symmetric.

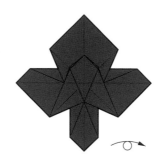

24 Turn over.

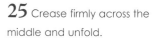
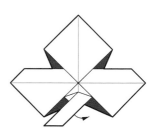

25 Crease firmly across the middle and unfold.

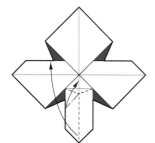

26 Swing the stem as far as it will go to form a rabbit's ear.

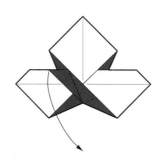

27 Unfold to Step 26.

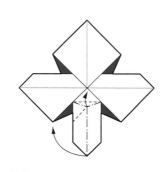

28 Refold along the same creases, turning the rabbit's ear inside-out.

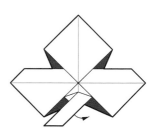

29 Pull out loose paper as far as it will go.

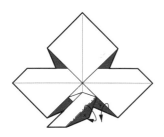

30 Turn flap X inside-out along existing creases. It is necessary to open up flap Y and then close Y when the operation is finished.

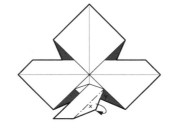

31 X is white. Y remains colored. Mountain-fold X underneath.

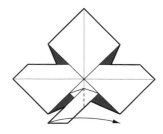

32 Swing the stem to the right. Then repeat Steps 29 through 31 on the opposite side of the stem.

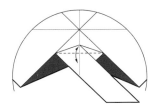 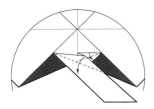 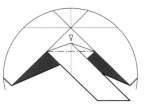 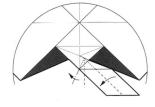

33 Valley-fold firmly and unfold.

34 Open-sink along existing creases.

35 Spread the paper along existing creases and squash downward.

36 Narrow stem with a long valley-fold. A tiny crimp will form automatically.

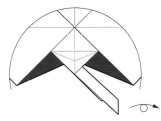 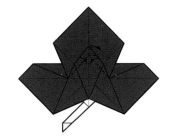 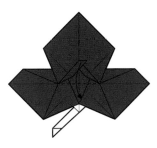

37 Completed stem. Turn over.

38 Form a tiny rabbit's ear with the long valley-folds parallel to the edges of the central flap.

39 Valley-fold central flap and tuck tip into pocket, locking the front of the model.

Completed Maple Leaf.

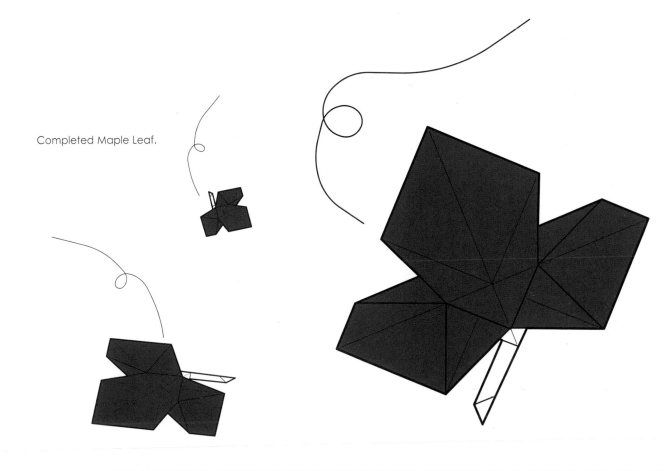

Begonia Leaf

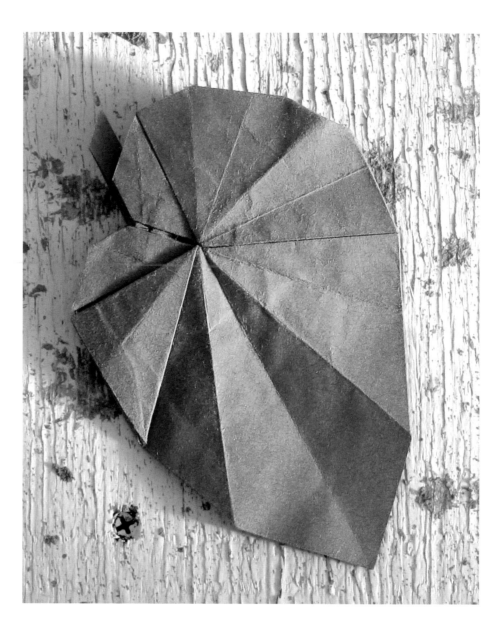

A 6-inch (25-cm) square produces a leaf 5 $1/2$ inches (14 cm) from stem to tip.

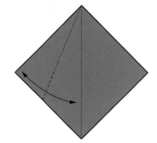

1 Use strong, very thin paper creased vertically. Fold edge to centerline, but pinch only at lower edge.

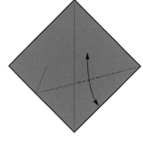

2 Pinch to the right of centerline.

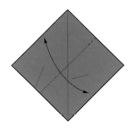

3 Fold paper in half and pinch at upper edge.

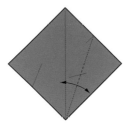

4 Pinch where creases cross.

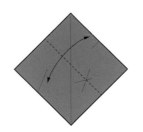

5 Crease firmly where creases cross and unfold.

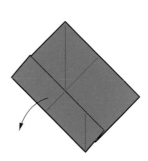

6 Crease firmly and unfold. Turn over.

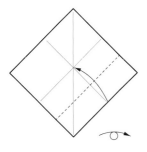

7 Valley-fold to existing crease and turn over.

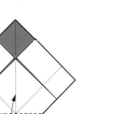

8 Valley-fold top layer only and swing rear layer to front.

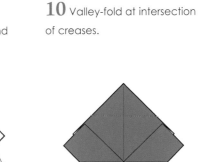

9 Unfold and turn over. Repeat 7 and 8 on left-hand side.

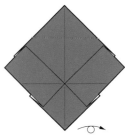

10 Valley-fold at intersection of creases.

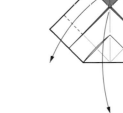

11 Reverse-fold along existing creases.

12 Valley-fold firmly.

13 Keeping the lower triangle folded flat against the adjacent paper, spread and squash the four corners along existing creases.

14 Turn over.

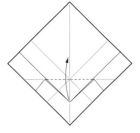

15 Swing triangle upwards.

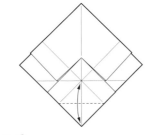

16 Crease lightly and unfold.

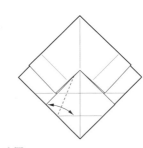

17 Valley-fold so that the lower left-hand edge becomes horizontal. Unfold.

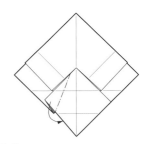

18 Reverse-fold the crease just made.

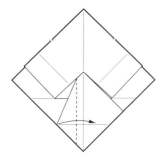

19 Valley-fold where crease falls naturally.

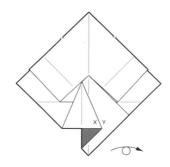

20 Turn creases inside-out and put X under Y. Turn over.

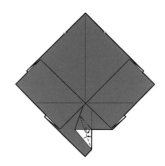

21 Valley-fold and tuck loose paper underneath.

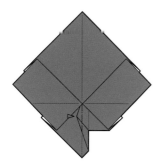

22 Open-sink to midline.

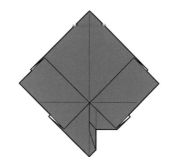

23 Repeat 17 to 22 on opposite side.

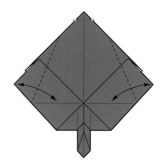

24 Valley-fold firmly so that lower edges meet existing horizontal crease. Unfold.

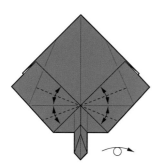

25 Crease carefully. Make creases one at a time and unfold them. The model will not lie flat during this step. Turn over.

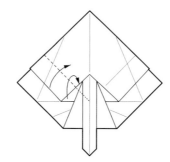

26 Reverse-fold along existing creases.

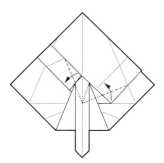

27 Simultaneously pivot two flaps counterclockwise and flatten.

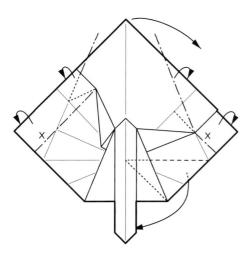

28 Swing tip of paper clockwise. Simultaneously, spread out the paper at both sides to form "pockets" and tuck them behind. The two new creases in this step are marked by an X and will automatically form perpendicular to the cut edge of the paper. All other folds occur along existing creases.

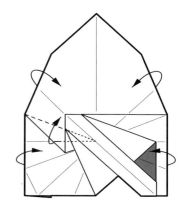

29 Refold the little flap at left. Carefully turn the two pockets inside-out, opening up the paper as necessary.

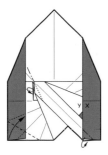 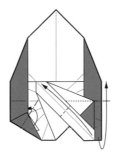 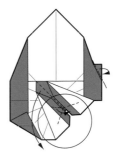

30 Lock the little flap near the center of the paper with a hidden mountain fold (tweezers will help). Valley-fold corner of the paper at lower left so that crease meets endpoints of existing creases. Mountain-fold corner of the paper at lower right. Then tuck X under Y.

31 Lock corner of paper at lower left with a hidden mountain fold. Swing stem up and to left. Swing lower right-hand corner of paper up behind the model along existing crease.

32 Form a tiny rabbit's ear to narrow stem. Circle shows area of detail in next steps. Mountain-fold tiny triangular flap at right to match edge of leaf.

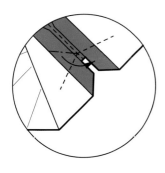 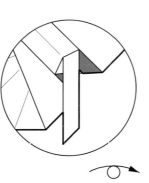 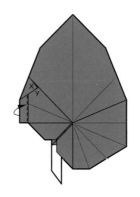 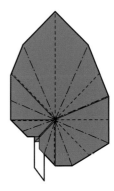

33 Detail showing rabbit's ear of stem.

34 Completed stem. Turn model over.

35 Tuck tiny flap X into pocket behind Y. Then valley-fold entire edge flap and tuck into pocket behind Y.

36 Add two new radial creases and recrease existing radial creases.

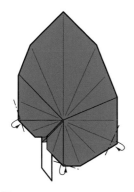

37 Shape edges of leaf as desired.

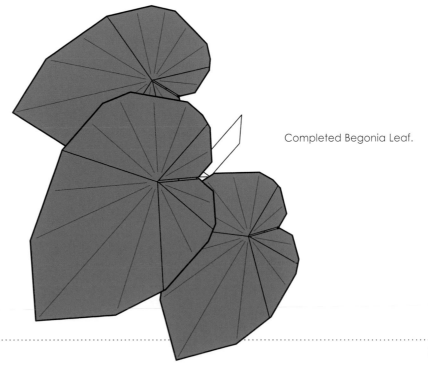

Completed Begonia Leaf.

Gingko Leaf

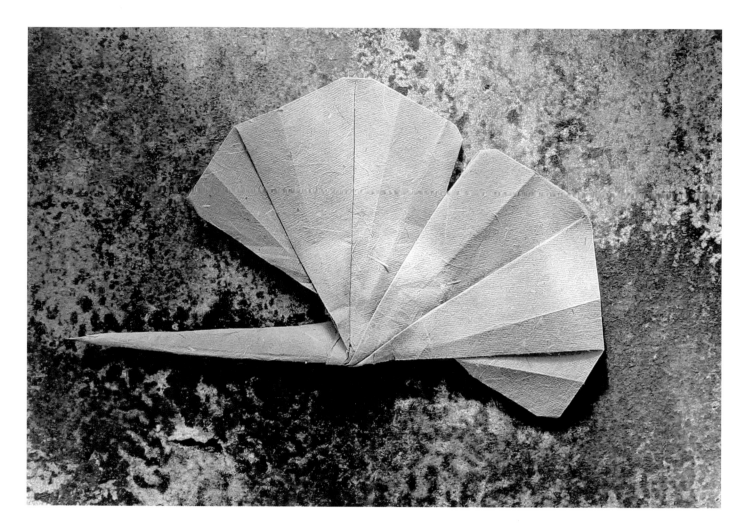

A 6-inch (25-cm) square produces a leaf 5 $^1/_4$ inches (13 cm) wide.

1 Use strong, very thin paper creased vertically. Valley-fold edges to centerline and unfold. Fold tip triangle down where creases meet edges.

2 Valley-fold so left-hand edge lands on right-hand crease.

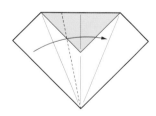

3 Unfold.

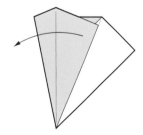

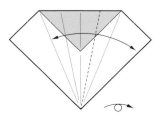

4 Repeat Steps 2 and 3 on right-hand side, then turn over.

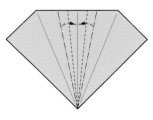

5 Fold existing mountain-folds to centerline.

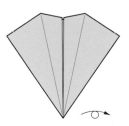

6 Step 5 completed. Turn over.

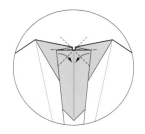

7 Enlarged view. Swing down horizontal edges on each side to meet centerline. A horizontal mountain-fold forms on the narrow flaps behind, and the paper stretches.

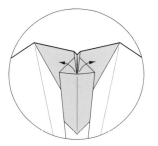

8 Note that the bottom edges just formed are not horizontal. Unfold.

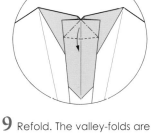

9 Refold. The valley-folds are not horizontal. The creases will be firm, but the model will not lie flat.

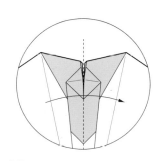

10 Valley-fold the entire model along the centerline and swing the left-hand side over to the right. Rotate model to position shown in next step.

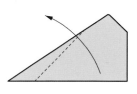

11 Valley-fold so the model lies flat.

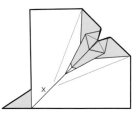

12 Step 11 completed. Unfold flap X and swing it behind. The next diagram shows this in process.

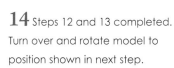

13 The mountain-fold becomes a valley-fold and vice versa.

14 Steps 12 and 13 completed. Turn over and rotate model to position shown in next step.

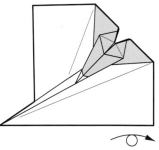

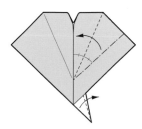

15 Valley-fold along the existing crease. The mountain-fold forms where the paper reaches the centerline.

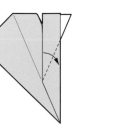

16 Fold over at edge behind.

17 Mountain-fold flap to the left where it falls naturally.

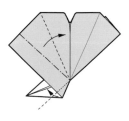

18 Repeat Step 15 on left-hand side.

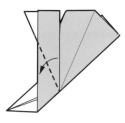 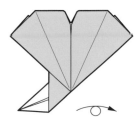 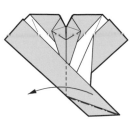 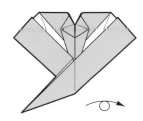

19 Repeat Step 16 on left-hand side.

20 Turn over.

21 Swing lower flap to left and mountain-fold along edge.

22 Turn over.

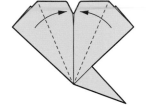 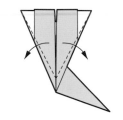 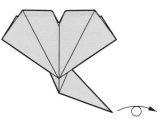 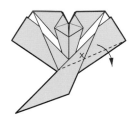

23 Fold edges to centerline.

24 Valley-folds reach corners at top.

25 Turn over.

26 Carefully disentangle and stretch paper at X, and then valley-fold, stretching as far as possible.

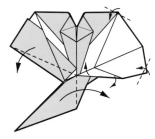 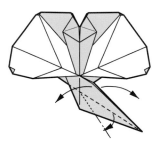 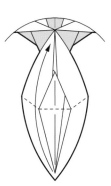

27 Swivel tiny white flap near center clockwise until it is taut. Repeat Step 26 and then this swivel procedure on left-hand side. Round corners on right-hand side, and repeat on left. Swing stem to right.

28 Spread sides of stem by poking finger in at top and squashing the central flap. The next diagram shows the central flap flat with the sides spread open.

29 Swing up the tip and flatten.

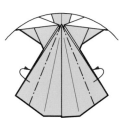 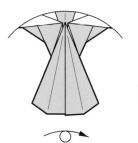

30 Reverse-fold edges to meet existing creases.

31 Turn over.

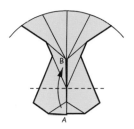

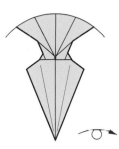

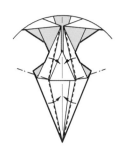

32 Valley-fold top flap only so point A lands slightly below B. The bottom of the flap swings to the front.

33 Step 32 completed. Turn over.

34 Narrow stem along edges with a kind of rabbit's ear.

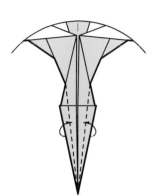

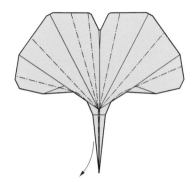

35 Roll paper over to narrow stem further. Note that the right side is thicker than the left.

36 Form crisp mountain-folds in an irregular pattern, then flatten firmly. Curl stem.

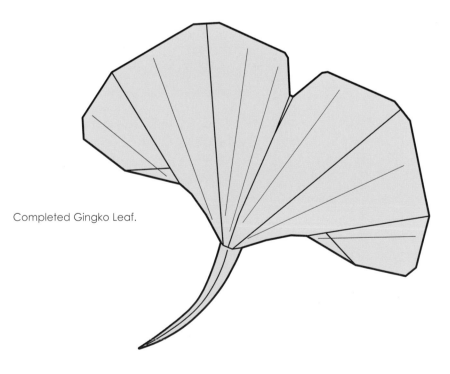

Completed Gingko Leaf.

Bodhi Leaf

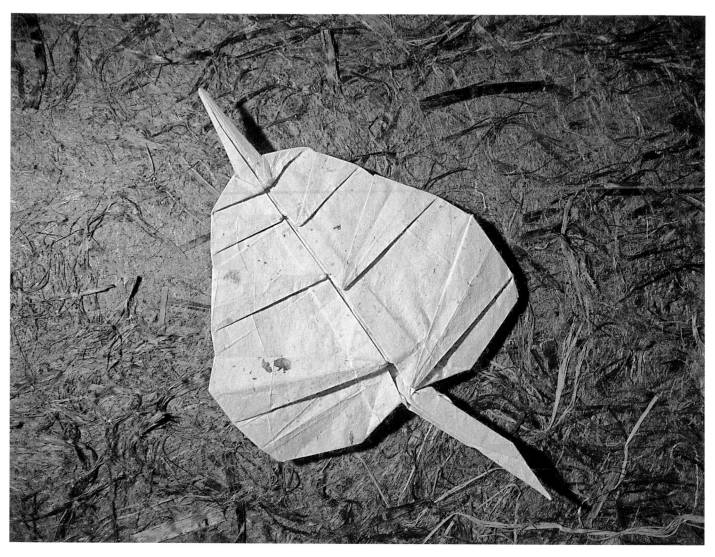

A 6-inch (25-cm) square produces a leaf 5 inches (13 cm) from stem to tip.

The Bodhi Leaf has both a symmetric and an asymmetric version. Fold the symmetric one first, beginning with Step 1. As the captions indicate, there are several opportunities for varying the leaf shape as you go along. I advise following the directions exactly the first time through. To produce the asymmetric leaf, fold up to Step 34 and proceed to the next section on page 89.

Symmetric Leaf

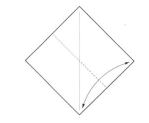

1 Use thin, strong paper. For your first attempt, use paper at least 10 inches square. Begin with the diagonal creased with a valley-fold. Valley-fold from edge to edge, creasing only near the lower right-hand edge, and unfold.

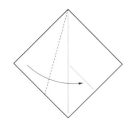

2 Valley-fold so the left-hand corner lands on the crease made in the previous step.

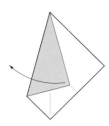

3 Unfold.

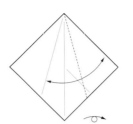

4 Valley-fold upper right-hand edge to crease made in Step 2 and unfold. Turn over.

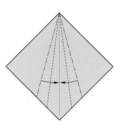

5 Pivot the mountain-folds so they fall on the centerline, forming new valley-folds. Next drawing shows a gap for clarity.

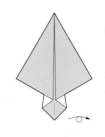

6 Turn over.

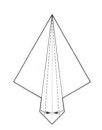

7 Valley-fold each edge to just shy of the centerline.

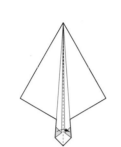

8 Valley-fold the left-hand flap over to the right.

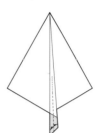

9 Creasing only about one-third of the way up the model, valley-fold the right-hand edge to the centerline, press firmly, and unfold. Return to position in previous step and repeat on the opposite side. These creases will be used in Step 22.

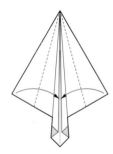

10 Valley-fold edges to centerline all the way to upper tip.

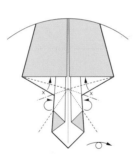

11 Valley-fold edges marked X to meet horizontal edges above. Mountain- and valley-folds will form on the hidden paper in the stem as it pivots upwards. Turn over.

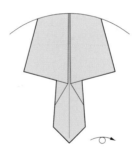

12 View of the rear. Turn over.

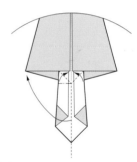

13 Swing stem up to the left to where it falls naturally, forming a rabbit's ear.

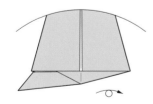

14 Turn over.

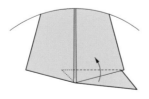

15 Swing stem upward through central slot with a valley-fold, creasing lightly.

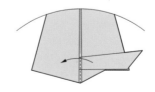

16 Valley-fold stem to left.

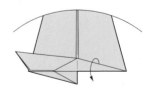

17 Open up slightly and pull out loose paper.

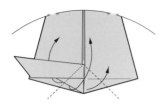

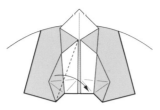

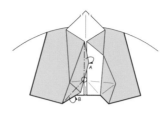

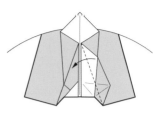

18 Swing sides of stem up and out and flatten firmly.

19 Valley-fold from corner to corner

20 Narrow flap A to the centerline with a mountain-fold. Narrow flap B to the new intersection, marked with a circle.

21 Repeat the last two steps on the right-hand side.

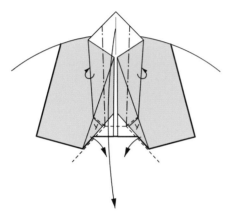

22 The folds in this step must be made simultaneously in order for the paper to flatten. Refold the creases made in Step 9. Swing the stem downward and the little flaps marked Y toward the center with valley-folds. A horizontal valley-fold will form where the stem meets these valley-folds. The result is a kind of rabbit's ear.

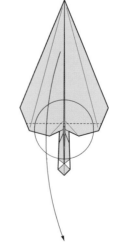

23 Unfold the two large flaps and turn over.

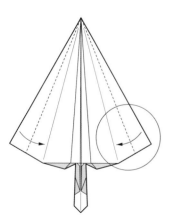

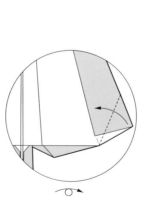

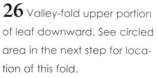

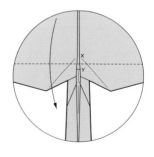

24 Valley-fold edges to creases. (You can create a narrower leaf by folding the sides in further.) Circled area shows detail in next step.

25 Valley-fold edge to edge. Repeat on left-hand side and turn over.

26 Valley-fold upper portion of leaf downward. See circled area in the next step for location of this fold.

27 Valley-fold falls halfway between point X, where diagonal creases meet at centerline, and Y, tiny horizontal crease visible through slot.

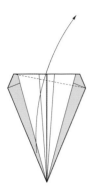

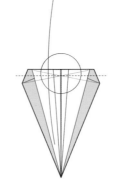
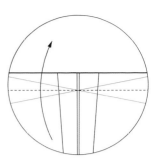

28 Valley-fold from corner to corner.

29 Unfold. Repeat previous step on right-hand side, ensuring that the two creases cross at the centerline. Unfold to position in previous step.

30 Valley-fold at the intersection of the two diagonals. See circled area in the next step for location of this fold.

31 Note position of valley-fold.

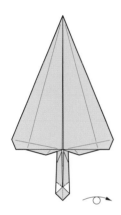
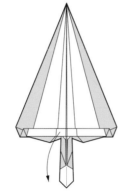
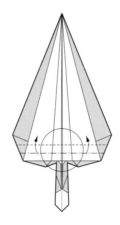
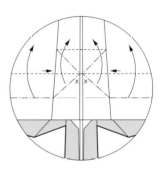

32 Turn over.

33 Open out.

34 Refold the horizontal mountain and valley-folds while adding new creases at the center. See circled area in next diagram for location of folds.

35 While refolding the horizontal mountain and valley-folds, push in at the short horizontal arrows and pry the triangular flaps marked X out of the paper. Flatten them upwards, forming angled mountain-folds in the process.

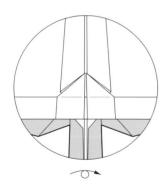
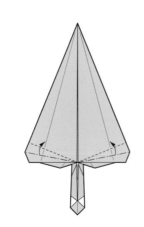
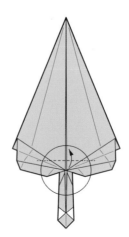

36 Procedure completed. Turn over.

37 Mountain-fold along the existing creases. The valley-folds form automatically.

38 Lift up the loose flap that stretches the entire width of the model, creasing as lightly as possible. The circle shows the detail in the next step.

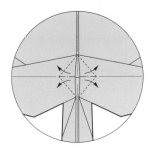

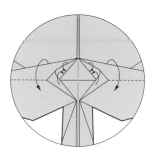

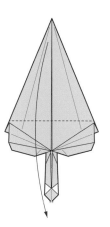

39 We are looking at the underside of the wide flap, which is standing up. Swing the loose paper at the center out to either side.

40 This is a difficult procedure best done with tweezers. Tuck the loose paper into the upper pockets and simultaneously close the wide flap to lock the model.

41 First pair of triangular lobes completed. Valley-fold horizontally slightly above the pointed corners near the sides of the leaf. You can vary the leaf shape by choosing the location of this crease.

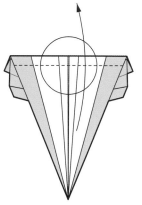

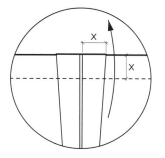

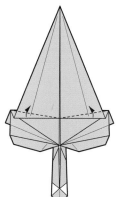

42 Valley-fold upward. The circle shows the detail in the next step.

43 The two dimensions must be equal for the succeeding steps to work properly.

44 Turn over.

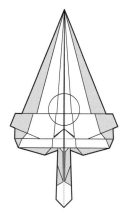

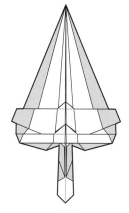

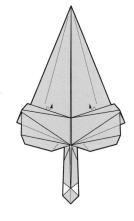

45 Repeat Steps 33, 34, and 35. The circle corresponds to the circled portion in Steps 35 and 36.

46 Turn over.

47 Valley-fold from corner to center.

48 Pull out loose paper and flatten on existing creases to create two additional lobes. You can vary the leaf shape by increasing the angle of the lobes.

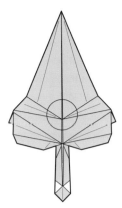

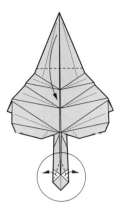

49 Repeat Steps 38 through 40 in the circled portion. The second pair of lobes is complete.

50 Valley-fold downward as in Step 41, choosing your desired location for this crease. Repeat Steps 42 through 49 to create a third pair of lobes.

51 The third pair of lobes is complete. Valley-fold downward, as in Step 41, choosing your desired location for this crease. Repeat Steps 42 through 49 to create a fourth pair of lobes. At the base of the stem, swing the two sides out with valley-folds. There is no exact location for the top of these folds. The circle at bottom shows the detail in the next two steps.

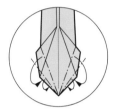

52 Narrow the base of the stem with mountain-folds.

53 Completed stem.

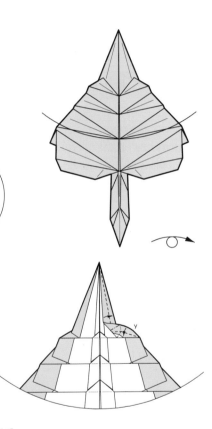

54 Fourth pair of lobes completed. The arc shows the detail in the next three steps. Turn over.

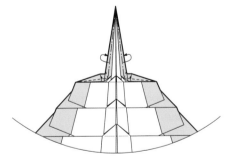

55 In this complex 3-D fold, the paper will not lie flat until both this and the next step are completed. Valley-fold so that the right-hand colored edge meets the center-line. The paper at the base of the valley-fold will stretch, and a tiny gusset-flap will form. Although a mountain-fold is shown where the white and colored paper meet, do not make this crease until the next step.

56 Once the colored edge meets the centerline, begin to fold it back upon itself, forming a valley-fold where the white and colored paper meet (this is the back side of the mountain-fold shown in the previous step). In order to flatten the paper, it is necessary to swing down the paper at Y with a valley-fold. With all the folds in place, the paper should lie flat.

57 The outside edge of the tip may overlap the edge beneath it. If so, narrow the outside edge of the tip still further, tucking the long edge behind with a mountain-fold aligning with the edge beneath. Repeat the two previous steps and this step on the left-hand side.

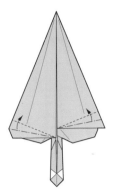 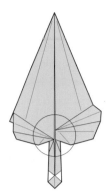 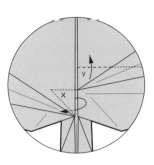

76 Crimp flaps upward as in Step 37.

77 The circle shows the detail in the next step.

78 Using tweezers, tuck the tiny hidden triangular flap at X into the pocket beneath it. Swing up flap Y as in Step 38 and perform Steps 39 and 40 on the right-hand side only.

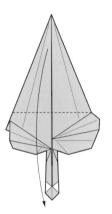 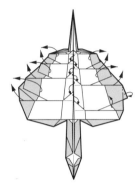 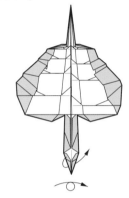

79 First pair of asymmetric lobes completed. Valley-fold horizontally just at the intersection at the right-hand edge. Repeat Steps 42 through 44. The circle in Step 45 brings you to the new asymmetric procedure shown in Step 67. Continue onward using the asymmetric procedures until you generate three pairs of lobes. Then produce the symmetric tip and pointed stem by following Steps 51 through 57.

80 Perform Steps 58 through 64 to lock sides and center of leaf.

81 Pinch stem and swing to one side. Turn over.

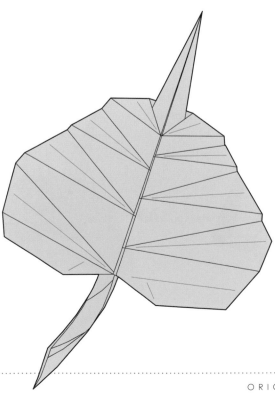

Completed asymmetric Bodhi Leaf.

Orchid

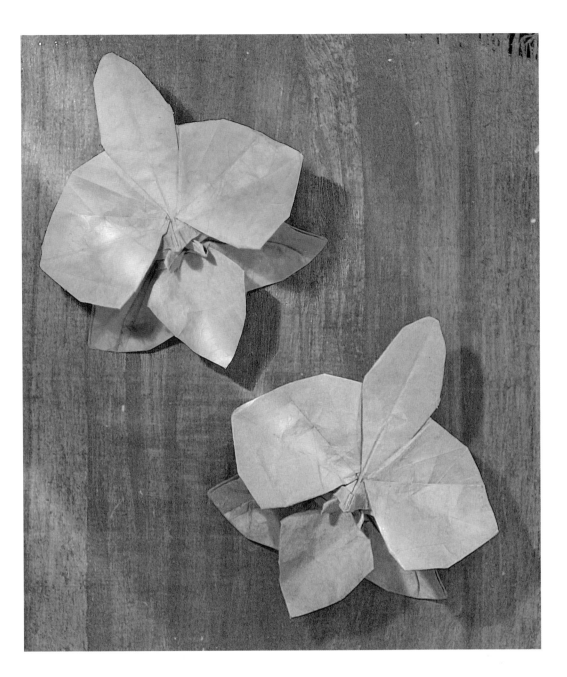

A 10-inch (25-cm) square produces a flower 6 1/4 inches (16 cm) tall.

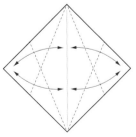

1 Begin by creasing along the diagonal. Valley-fold all four edges to the centerline and unfold.

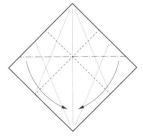

2 Valley-fold where two of the creases formed in the previous step meet the edge. Mountain-fold at the intersection of these two valley-folds and collapse the paper.

3 Valley-fold. Unfold the full square, leaving the colored side facing up.

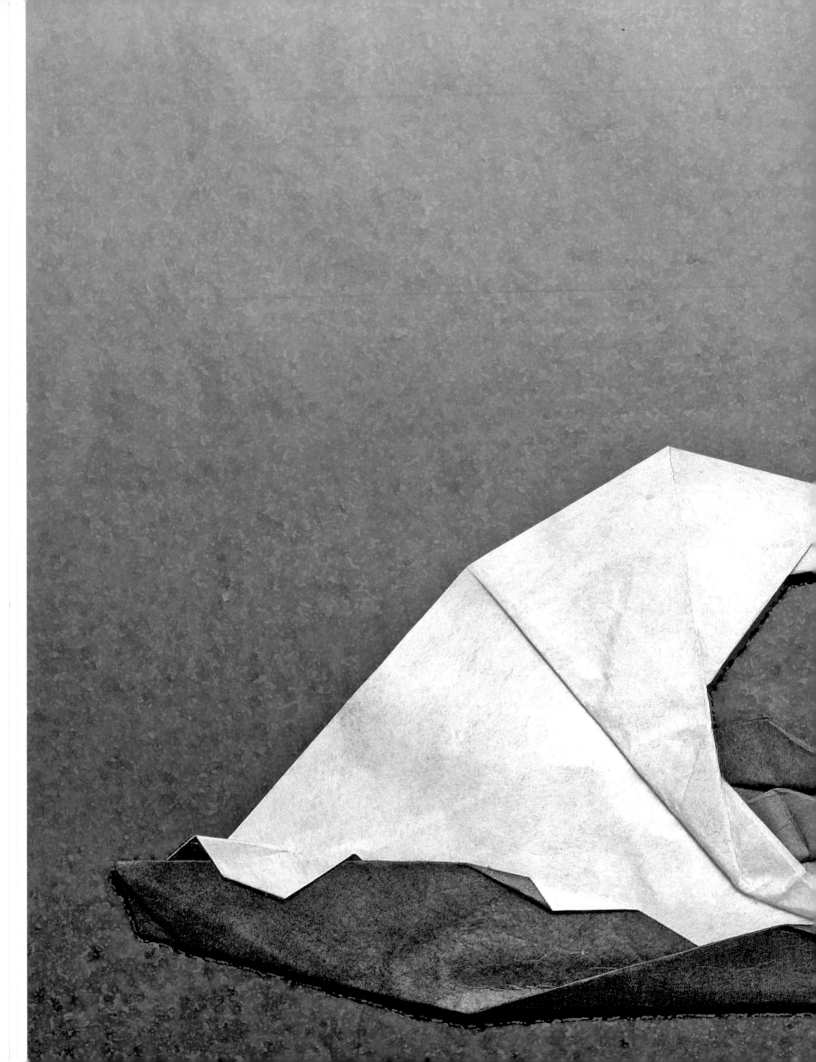

Ocean's Edge

Stingray

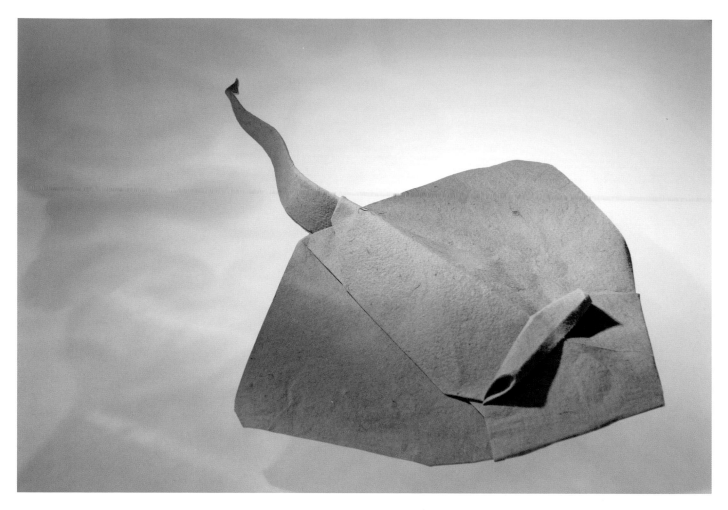

A 10-inch (25-cm) square produces a stingray 9 inches (23 cm) long.

1 Begin with paper creased vertically. Valley-fold edges to centerline and unfold. Turn over.

2 Valley-fold where existing crease meets edge and swing tip to right.

3 Unfold and repeat previous step on opposite side.

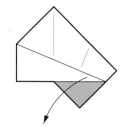

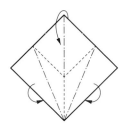

4 Swing sides behind and top forward, all along existing creases.

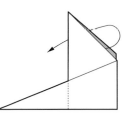

5 Swing rear flap behind and to left.

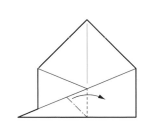

6 Spread and squash the central triangular flap.

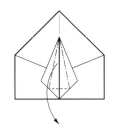

7 Swing the flap downward and simultaneously narrow the sides. Turn over.

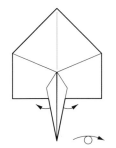

8 Pull out loose paper. Turn over.

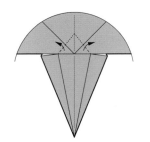

9 Valley-fold tiny flaps. Before folding, see next diagram for how to locate top of creases.

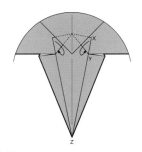

10 Edge XY aligns with edge YZ. Tuck each tiny flap underneath along existing creases (tweezers will help).

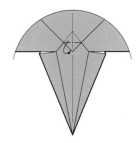

11 Tuck tiny central flap underneath where it meets adjoining edges.

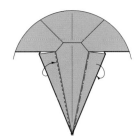

12 Tuck left-hand flap into pocket (the upper portion of the flap turns inside-out). Mountain-fold right-hand flap behind.

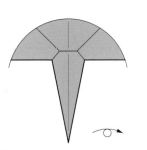

13 Turn over.

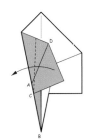

14 Valley-fold directly along edge AB.

15 Valley-fold through point C so that point D falls on the edge formed in the previous step.

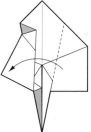

16 Repeat previous two steps on right-hand side.

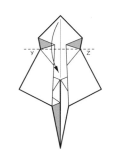

17 Valley-fold top flap. Note position of Y and Z in succeeding steps.

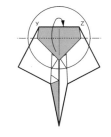

18 Mountain-fold white paper behind top flap where edges meet. Tip swings upward.

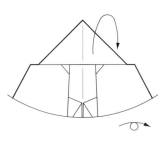

19 Swing down tip, undoing the crease made in Step 17.

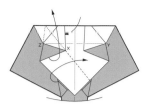

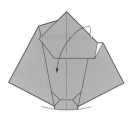
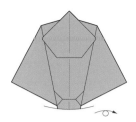

20 Place a finger in pocket at arrow facing left. Push in and gently spread out the pocket. Simultaneously, valley-fold through point X and swing it upward. Note that the valley-fold is not perpendicular to the edge at the bottom right.

21 Valley-fold along the existing, mostly hidden crease that is horizontal at Y. Where that crease hits the angled left-hand edge, simultaneously form a valley-fold to point X. The paper swings to the left.

22 Unfold to position in Step 20, and repeat Steps 20 and 21 on right-hand side.

23 Turn over.

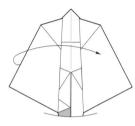

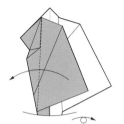
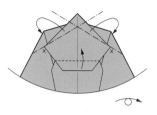

24 Swing flap to the right.

25 Valley-fold flap to just shy of existing crease.

26 Swing flap back to left. Turn over.

27 Swing flap at center of drawing upward as far as it will go, forming a horizontal valley-fold. Mountain-fold the upper left-hand side, and then repeat on the right-hand side. The angle of these folds is approximate, but they should pass through point X on each side. Turn over.

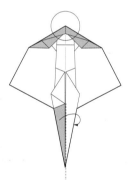

28 Valley-fold the tail and tuck the colored flap into the pocket to lock it. The body will bulge and become 3-D.

30 Squash and spread eyes. Fold tips of fins. Curve fins, body, and tail. Squash tip of tail to one side as shown in detail.

29 Valley-fold tiny hidden flap to lock head (tweezers will help).

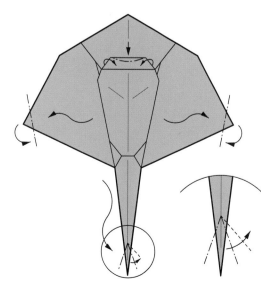

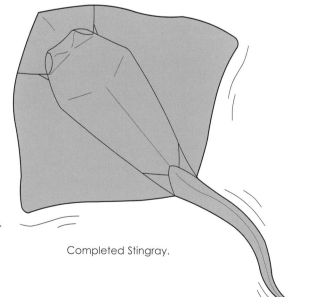

Completed Stingray.

Sea Turtle

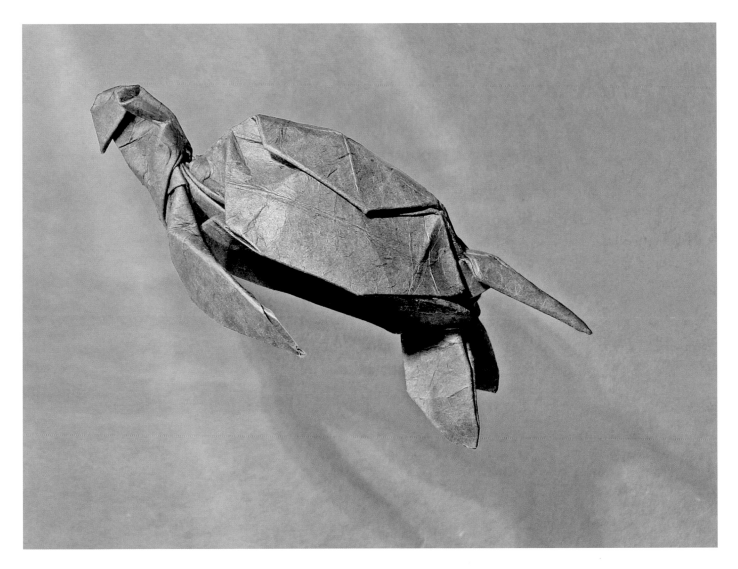

A 10-inch (25-cm) square produces a turtle 6 inches (15 cm) from tip to tip.

1 Use strong paper at least 15 inches square for your first attempt. Begin with diagonals valley-folded. Fold edge to edge and unfold.

2 Valley-fold opposite edges to centerline and unfold.

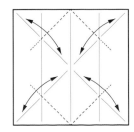

3 Valley-fold corners to center, creasing only where shown, and unfold.

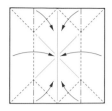 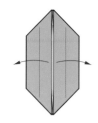 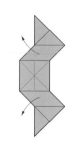 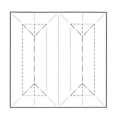

4 Collapse paper on creases formed in previous steps.

5 Valley-fold sides to center-line and unfold.

6 Open up entire square.

7 Refold just the creases shown.

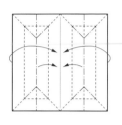 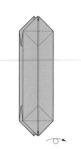 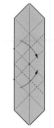 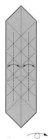 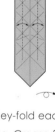

8 Collapse the entire square along existing creases.

9 Turn over.

10 Valley-fold. Note which points touch.

11 Unfold. Repeat Step 10 and this step on right-hand side.

12 Valley-fold. Note which points touch.

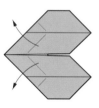 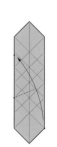 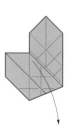

13 Unfold. Repeat Step 12 and this step on right-hand side.

14 Valley-fold where creases intersect at left-hand edge. Swing lower right corner up so it lands on left-hand edge below crease intersection. Valley-fold only to centerline.

15 Unfold. Repeat Steps 14 and this step on right-hand side.

16 Valley-fold each side to centerline. Crease firmly and only where shown. Turn over.

17 Grasp multiple thicknesses and swing out to sides. Flatten.

18 Turn over.

19 Narrow side flaps with valley-folds. Hidden mountain-folds form and hidden paper spreads and squashes flat.

20 Turn over.

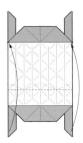 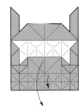 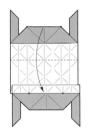 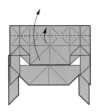

21 Valley-fold through intersections. Note where lower corners land.

22 Valley-fold through intersections. It may help to turn the paper over.

23 Valley-fold through intersections. Note which points touch. This is the mirror-image of Step 21.

24 Valley-fold through intersections. It may help to turn the paper over. This is the mirror-image of Step 22.

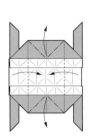 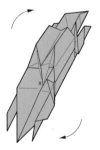

25 Collapse paper along existing creases.

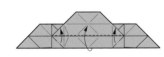

26 Turn over.

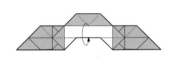

27 This is a difficult maneuver. All folds in this step are formed on existing creases. Valley-fold model along the centerline but keep sides slightly open. Reach in under model and push up where mountain-folds are shown. Simultaneously, push in at little arrows where valley-folds are shown. These valley-folds will become vertical and the center of the model will pop up. Continue pushing up from below while pressing down on central valley-fold. Form vertical mountain-folds at the two Xs. The model will begin to flatten from side to side.

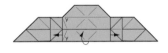

28 Step 27 nearly completed. Note the vertical mountain-fold at X. All creases must be exactly in place for model to flatten. Flatten completely and rotate so that model becomes horizontal.

29 Open the model, pull out loose paper left, right, front, and back (four locations), and re-flatten on existing creases.

30 Lift all layers up and simultaneously stretch paper along the diagonals, forming mountain-folds. Repeat behind.

31 Swing the top, all-white layer down, behind, and up into pocket behind. It will be necessary to open the model slightly. Repeat behind.

32 Swing all remaining layers down. Repeat behind.

33 Open up model and pull out trapped paper. Before closing model, look ahead to the next step to make sure the flaps marked X swing free. Repeat behind.

34 Swing all layers up. Repeat behind.

35 Swing the single-ply layer down, behind, and up into pocket behind. It will be necessary to open the model slightly. Repeat behind.

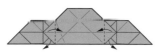

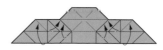

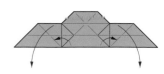

36 Swing the sole remaining flap down. Repeat behind.

37 Swing the triangular flaps toward the center of the diagram and pull out loose paper. Repeat behind.

38 Swing horizontal flaps upward and pivot other paper as shown. Repeat behind.

39 Swivel top flap at front and rear out and down. The paper unfolds automatically. Repeat behind.

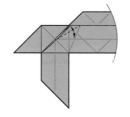

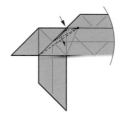

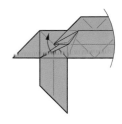

40 Check again to make sure crease Y is on the left-hand side. Swing central flap upward. Repeat behind.

41 This diagram through Step 64 shows the left-hand (head) side of the model. Do not repeat these procedures on the right-hand (tail) side. Valley-fold firmly from intersection to intersection and unfold. Repeat behind.

42 Valley-fold carefully from intersection to intersection. The paper will not yet lie flat. Then push in at arrow and squash paper flat so that a hidden valley-fold forms along the crease made in Step 41 (shown dotted in this diagram). An additional mountain-fold will form as shown.

43 Open up and return to position in previous step.

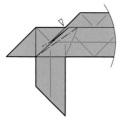

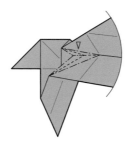

44 Open-sink along the creases formed in the previous steps. Reach into the model to turn creases in the proper direction and help loose interior layers flatten. Note that the two left-hand legs of the sink are different lengths.

45 The open-sink in progress. Complete and flatten. Repeat behind.

46 Crimp so that edge AB lands on diagonal BC. Note which creases are mountain-folds and which are valley-folds. All of the paper that swivels lands behind flap D. Repeat behind.

47 First stage of a complicated closed-sink fold: Lift paper at edge X into the air to make a hollow mountain-shape. At sink arrow, push little pyramid partway into hollow mountain-shape at mountain-fold Y. The model remains 3-D.

48 Second stage of the sink-fold: Many portions flatten simultaneously. Flap X swings up to return to its previous position. Flap A swings to the right. Flap B squashes flat, exposing flap C behind. With careful folding, all the layers will flatten cleanly. Repeat Step 47 and this step behind.

49 Valley-fold flap C against adjacent edge and tuck paper behind with a tiny mountain-fold. Repeat behind.

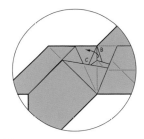

50 Swing flap C back to the left. Open the model slightly in order to pull out the trapped paper behind flaps B and C. Collapse the model cleanly. Repeat behind.

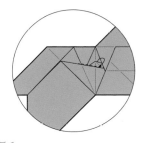

51 Swing the tiny flap down and out of sight. Repeat behind.

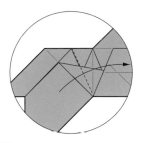

52 Swing left-hand flap over to the right. Repeat behind.

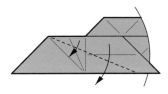

53 Fold edge to crease. Repeat behind.

54 Mountain-fold and tuck underneath.

55 Crimp front and back symmetrically so that edge XY lands on intersection marked with a dot. Valley-fold top down, front and back, to form a pair of rabbit's ears.

56 Form a hidden mountain-fold to tuck loose flap Z into the model and out of sight. Repeat behind.

57 Crease begins at base of neck and is parallel to edge at bottom. Repeat behind.

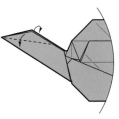

58 Valley-fold to tip. Right-hand side of crease ends where paper becomes thick. Repeat behind.

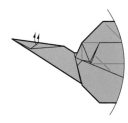

59 Valley-fold edge to edge. Repeat behind.

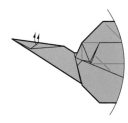

60 Pull out loose paper from inside. Repeat behind.

61 The circle shows the detail in the next diagram.

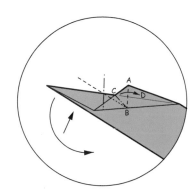

62 Complex 3-D fold. Valley-fold AB is perpendicular to crease D. From the base of AB, mountain-fold BC is perpendicular to the upper edge. To swing BC over AD, push in at bottom of model and crimp symmetrically. Hidden folds form automatically and the beak swings downward.

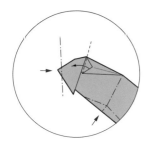

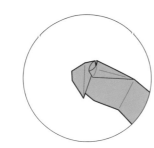

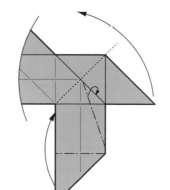

63 Swing the tiny triangular flap to the left and round it to form an eye. Repeat behind. Reverse-fold tip of beak. Round base of neck to form head.

64 Completed head.

65 This diagram through Step 75 show the right-hand (tail) side of the model. Note triangular flap below horizontal mountain-fold. Valley-fold at this location and unfold. Then reverse-fold triangular flap into the space above. Narrow flap at right with a mountain-fold. Crease lands just shy of upper and lower intersections. Repeat both procedures behind. Reverse-fold the tail upward through the center of the model.

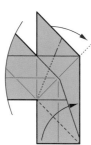

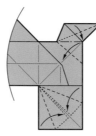

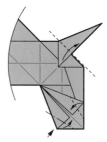

66 Valley-fold bottom triangular flap to the right to where it falls naturally. Repeat behind. Reverse-fold the tail so edge meets edge.

67 Valley-fold edges of bottom square. Creases meet upper corner. Lower portions of flaps land just shy of centerline. Narrow tail with a valley-fold and swing corner down where it falls naturally. Repeat behind.

68 Narrow rear flippers with valley-folds and one mountain-fold to create a pocket. Swing tail flap up and to the right. Repeat behind.

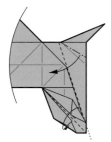

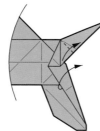

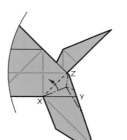

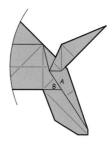

69 Valley-fold half of flipper and tuck protruding flap into matching pocket. Form a long valley-fold directly against the partly hidden rear side of the flipper. A mountain-fold forms above as the paper spreads flat. Repeat behind.

70 Unfold.

71 Swing both sides of corner flap over simultaneously. New valley-fold at left meets existing valley-fold at intersection X. Collapse paper where it lands naturally. Little creases shown at top right form automatically.

72 Tuck A under B and under the hidden triangular flap beneath B. Repeat behind.

73 Mountain-fold so XY lands on XZ. Crimp rear of flipper. Repeat behind.

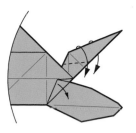

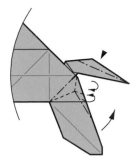

74 Unfold flipper to position in previous step. Repeat behind. Outside reverse-fold tail.

75 Refold flipper on existing creases, reversing direction of folds as necessary so flipper tucks inside body. Crimp sides of each flipper symmetrically so crimps meet each other. Repeat behind. Narrow tail with a closed-sink, pushing sunk flap to one side.

76 Completed rear flippers and tail.

77 Carefully closed-sink corners of shell. Crimp front flipper. Repeat behind.

78 Swing two flaps down. Repeat behind.

79 Rotate loose flaps at top of shell, gently stretching hidden paper.

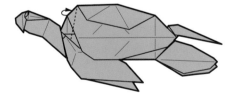

80 Lock top of shell by valley-folding hidden central flap to one side. Insert a finger into opening at bottom of shell to spread sides of shell and round bottom. Spread flippers.

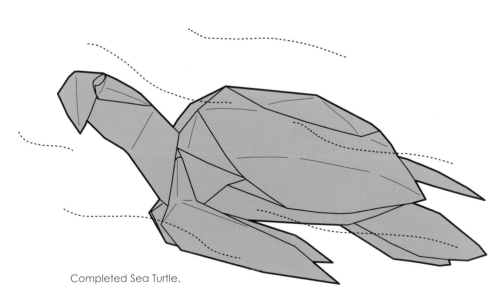

Completed Sea Turtle.

Whale

A 10-inch (25-cm) square produces a whale 6 1/2 inches (16 cm) from stem to stern.

1 Crease and unfold diagonals.

2 Fold upper edges to horizontal crease and unfold.

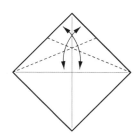

3 Fold tip to intersection and unfold.

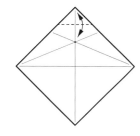

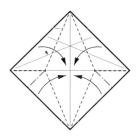 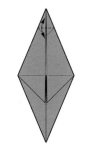 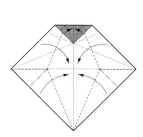 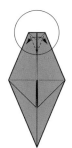

4 Valley-fold four edges to centerline, forming two rabbit's ears. The result is called a fish base.

5 Swing down the tip along the hidden crease made in Step 3, and unfold. Open the entire model, then fold down the tip as in Step 3.

6 Re-fold the creases in Step 4.

7 Swing flaps to the sides along existing creases. Circle shows area of detail in next step.

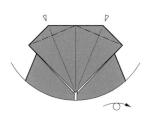 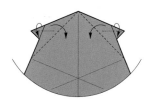 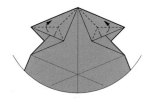 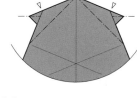

8 Open-sink along existing creases. Turn over.

9 Spread and squash flaps along existing creases.

10 Rabbit's ear upwards.

11 Open-sink along existing creases.

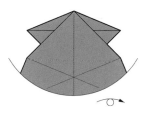 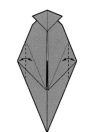 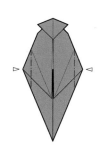 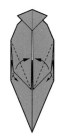

12 Turn over.

13 Valley-folds are vertical. Unfold.

14 Open-sink along existing creases.

15 Spread and squash along existing creases.

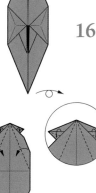 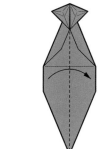 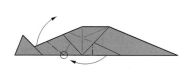 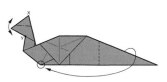

16 Turn over.

17 Bisect angle at top with valley-folds and simultaneously swing down little flaps on sides of tail. See detail.

18 Fold model in half and rotate.

19 Inside reverse-fold tail at circled intersection. Note location of tail in next diagram. Inside reverse-fold flippers on front and back so tip meets circled intersection.

20 Reverse-fold tail so tip X meets intersection Y and unfold. Outside reverse-fold head so tip meets circled intersection.

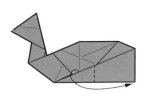 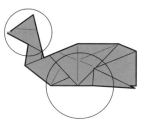 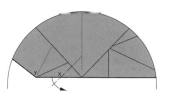 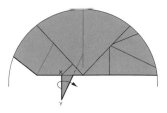

21 Outside reverse-fold head again—note that tip lands shy of front of head.

22 Circles show det ails of flippers (Steps 23 through 25) and tail (Steps 26 through 32).

23 Inside reverse-fold flipper so that edge XY becomes vertical (note that this divides angle into thirds). Repeat behind.

24 Note position of X and Y. Swing left-hand side of flipper over to right. Repeat behind.

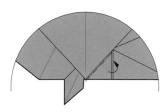 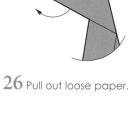 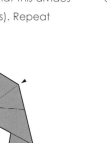 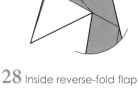

25 Tuck two layers of triangular flaps into pocket beneath to lock flipper. Repeat behind.

26 Pull out loose paper.

27 Closed-sink flap through existing crease.

28 Inside reverse-fold flap following existing hidden crease.

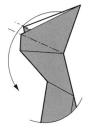 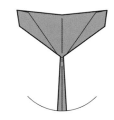

29 Inside reverse-fold tail fin where edges meet.

30 Spread tail.

31 View from back of tail. Rabbit's ear tip of central flap and tuck edges under side flaps.

32 Completed tail. Keep spread slightly.

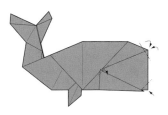

33 Valley-fold rear corner of mouth flap to produce an eye. Repeat behind. Round front of head with mountain folds. Blunt tip of head with a tiny reverse-fold.

Completed Whale.

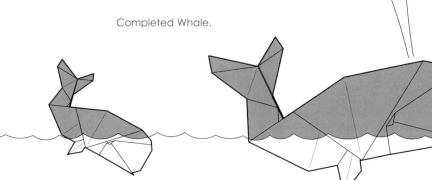

Seagull

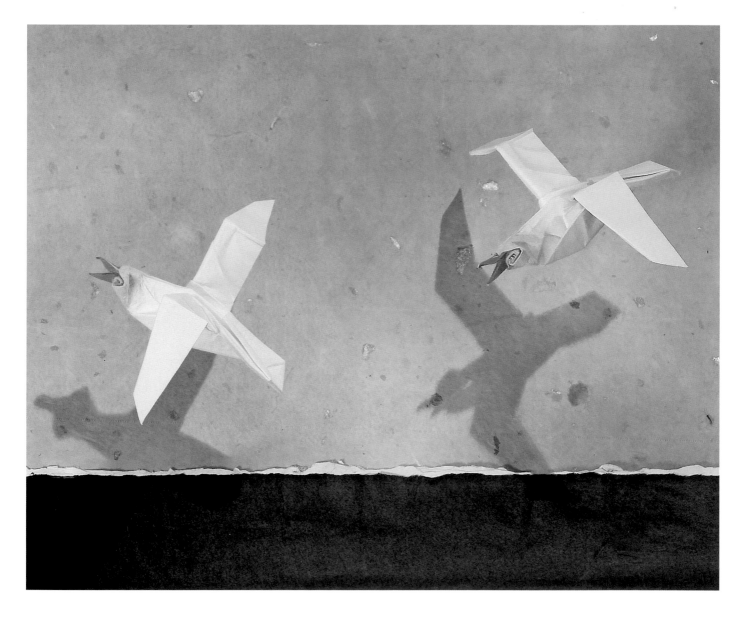

A 10-inch (25-cm) square produces a seagull 4 1/4 inches (11 cm) long with a 6 3/4-inch (17-cm) wingspan.

1 Begin with paper creased along one diagonal. Fold bottom tip upward to meet top tip.

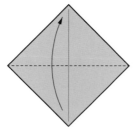

2 Valley-fold top layer down so tip touches edge, and unfold.

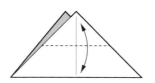

3 Fold double thickness up to meet crease formed in previous step.

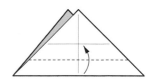

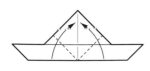

4 Valley-fold so bottom edges meet centerline.

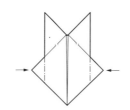

5 Diagram enlarged. Reverse-fold tips at hidden thickness.

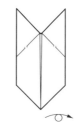

6 Step 5 completed. Turn over.

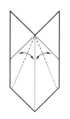

7 Valley-fold full thickness at top only and unfold.

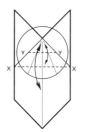

8 Valley-fold through X's and unfold. Then valley fold so tip meets that crease and unfold. Circle shows enlargement in next step. Note location of edge YY.

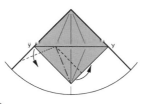

9 Swing tip to right by turning existing valley fold into a mountain fold.

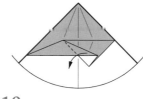

10 Swing flap down.

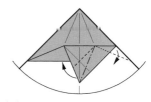

11 Repeat Steps 9 and 10 on opposite side.

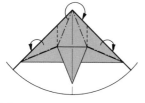

12 Repeat Steps 9 through 11 facing the rear, or fold in a single step as shown.

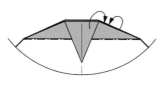

13 Mountain-fold front flap and valley-fold rear flap exactly at edge.

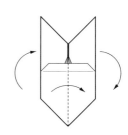

14 Step 13 completed.

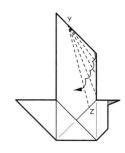

15 Valley-fold entire model in half and rotate counter-clockwise.

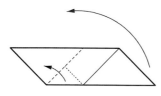

16 Swing flaps up in front and behind as far as they will go.

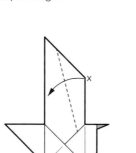

17 Valley-fold so point X touches vertical edge. There is no exact location for this fold. Repeat behind.

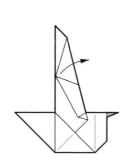

18 Unfold. Repeat behind.

19 YZ is the existing crease. Divide the angle into fourths, rolling the paper over and over. Allow room for the thickness of the paper so the result is tightly wound. Repeat behind.

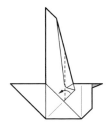

20 Valley-fold is vertical. The paper becomes thick but should hold in place. Repeat behind.

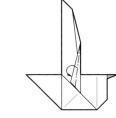

21 Narrow flap in half with a mountain-fold. Repeat behind.

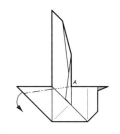

22 Inside reverse-fold tail to point A at the front of the wings, as far as it will go. There is no exact location for the rear of this fold.

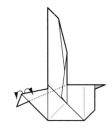

23 Open up model and turn tail inside-out.

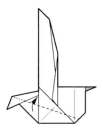

24 Valley-fold flap upward and tuck tightly into intersection of tail and wing. Repeat behind.

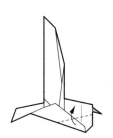

25 Inside reverse-fold top of body to a point below the beak.

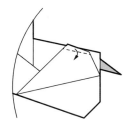

26 Lightly valley-fold bottom of body to another point below the beak. Do not press flat.

27 Valley-fold tip of flap so it lands some distance below the top of the body.

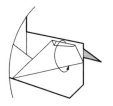

28 Tuck flap inside body along crease formed in Step 26, and press firmly. Repeat steps 26, 27, and this step behind.

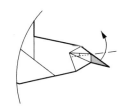

29 Stretch white paper to left to form eye. Repeat behind.

30 Separate upper beak from lower and inside reverse-fold upward.

31 Spread eye, revealing colored paper. Curl tip of upper beak downward.

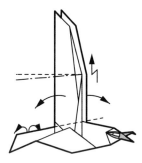

32 Spread tail. Crimp wings and valley-fold where wings meet body.

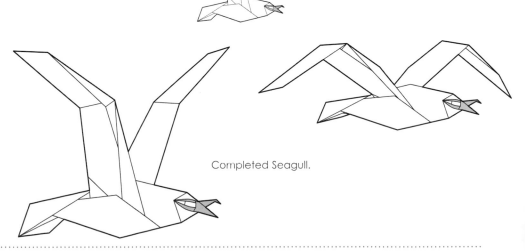

Completed Seagull.

Waves

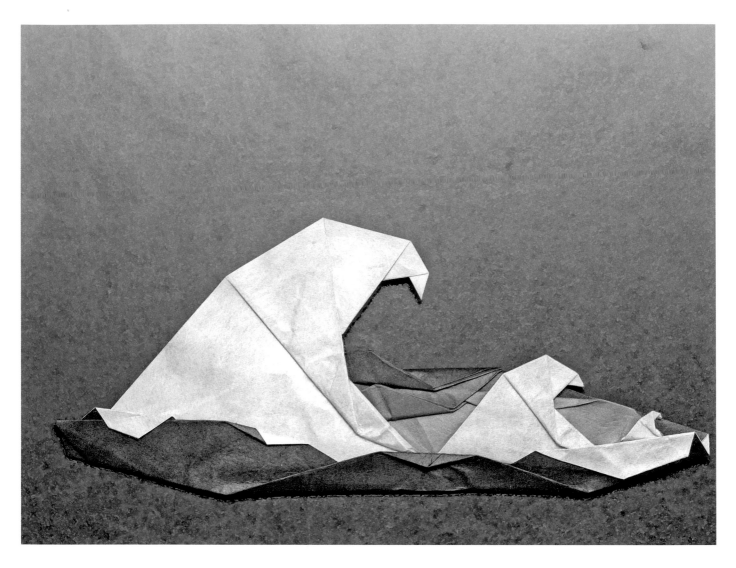

A 10-inch (25-cm) square produces a wave model 9 ¹/₂ inches (24 cm) wide.

1 Valley-fold along the diagonal and unfold. Turn over.

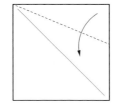

2 Valley-fold edge to diagonal crease.

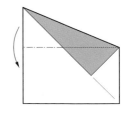

3 Mountain-fold horizontally at right-hand intersection without creasing colored flap. The flap swings upward.

4 Valley-fold directly on top of hidden edge.

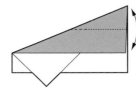

5 Valley-fold top right point to colored corner, pinching where crease meets angled edge.

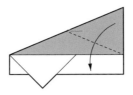

6 Valley-fold from pinch mark to colored corner.

7 Unfold.

8 Open-sink through the crease just created. To do so, open paper completely and see next step.

9 Orient creases as shown and refold paper.

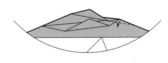

10 The little water crests formed in this and the succeeding steps can be varied as desired. Follow the indicated crease lines the first time. Valley-fold front flap. Right-hand side of crease goes to hidden corner. Tip touches horizontal colored edge.

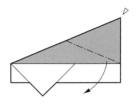

11 Valley-fold rear flap. Right-hand side of crease goes to hidden corner. Angle is arbitrary, but tip should overlap edge below.

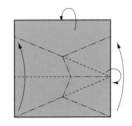

12 Valley-fold rear flap from upper left corner so tip protrudes on top.

13 Valley-fold front flap so tip protrudes above edge.

14 Valley-fold the front flap as desired. Part of the flap remains hidden.

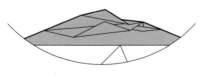

15 Water crests completed.

16 Swing white flap upward as far as it will go and flatten.

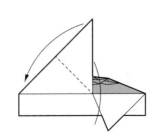

17 Valley-fold white flap in half. The arc shows the detail in the succeeding diagrams.

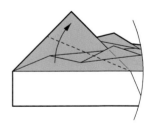

18 The proportions of the large wave formed in this and the succeeding steps can be varied as desired. Follow the indicated crease lines the first time. Valley-fold edge to edge.

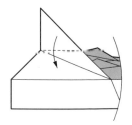 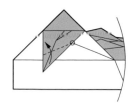 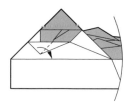 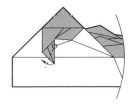

19 Valley-fold horizontally from the left-hand intersection.

20 Valley-fold diagonally from the right-hand intersection so that the angled edge becomes horizontal.

21 Valley-fold diagonally from the bottom intersection so that the top edge becomes vertical.

22 Valley-fold diagonally from the right-hand intersection so that a portion of the angled edge becomes horizontal.

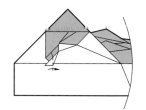 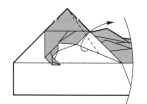 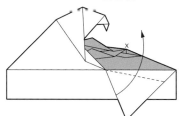

23 Valley-fold vertically from the bottom intersection.

24 Valley-fold from the upper intersection at an arbitrary angle in order to pivot the wave up and to the right.

25 As with the large wave, the proportions of the medium-sized wave formed in this and the succeeding steps can be varied as desired. Follow the indicated crease lines the first time. Valley-fold so that angled edge lands on point X.

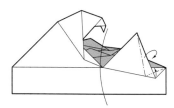 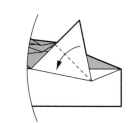 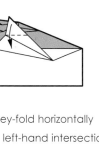

26 Valley-fold the white flap at the far right of the model so that edge meets edge. Simultaneously swing the right-hand side of the larger flap behind with a mountain-fold.

27 Valley-fold edge to edge.

28 Valley-fold edge to edge.

29 Valley-fold horizontally from the left-hand intersection.

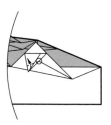 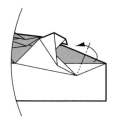

30 Valley-fold diagonally from the right-hand intersection so that a portion of the angled edge becomes horizontal.

31 Valley-fold diagonally from the bottom intersection so that the top edge becomes vertical.

32 Valley-fold through the circled intersection in order to pivot the wave up and to the right.

33 Mountain-fold the colored flap behind. The crease is perpendicular to the upper edge.

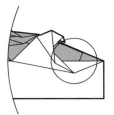

34 The circle shows the detail in the succeeding diagrams.

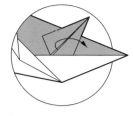

35 Valley-fold the front layer vertically from the hidden intersection, swinging the hidden point to the right.

36 Pull out loose paper and flatten.

37 Swing colored paper behind.

38 Pull out loose paper and flatten.

39 As with the large and medium-sized wave, the proportions of the small wave can be varied as desired. Follow the indicated crease lines the first time. Valley-fold edge to edge as in Step 17. Repeat Steps 18 through 21. Then swing wave up and to the right as in Step 24.

40 Completed small wave.

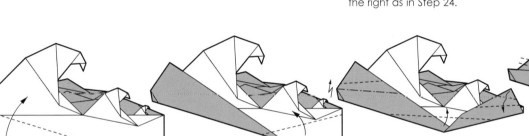

41 The little water troughs formed in this and the succeeding steps can be varied as desired. Valley-fold at an arbitrary angle.

42 Valley-fold at an arbitrary angle.

43 Valley-fold and mountain-fold as desired.

44 Valley-fold as desired.

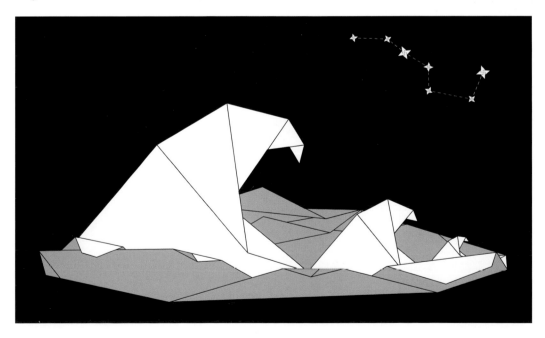

Completed Waves.

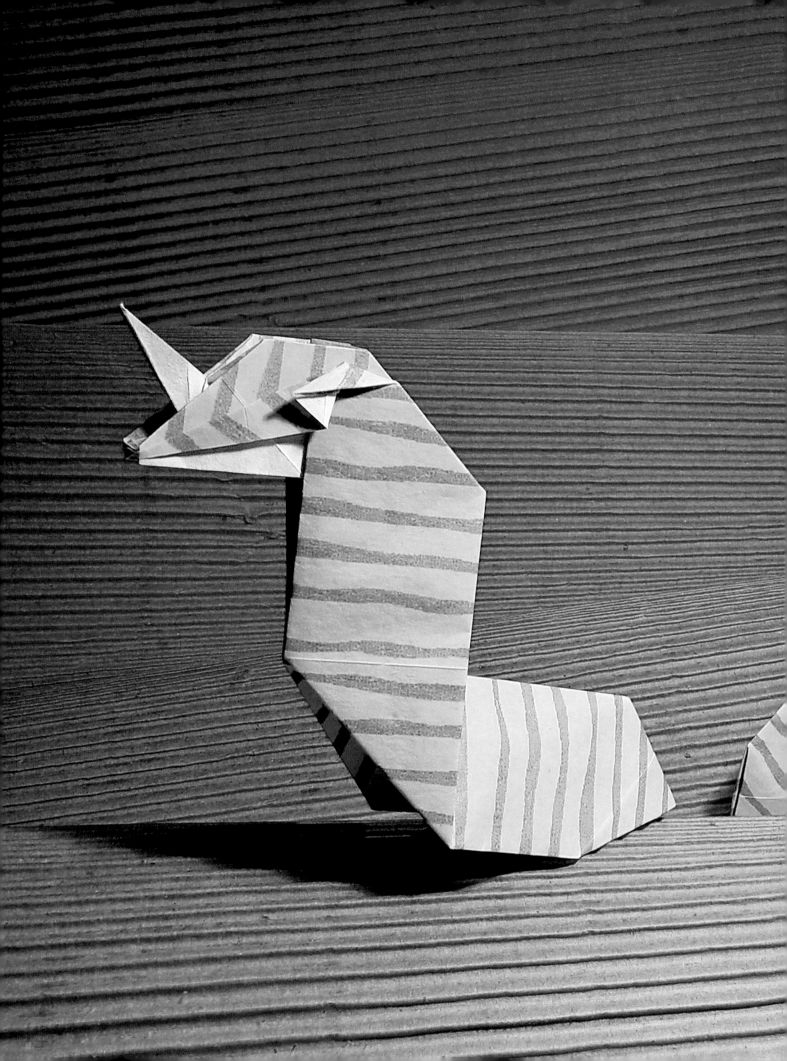

CHAPTER 5

Myth and Play

Forest Troll

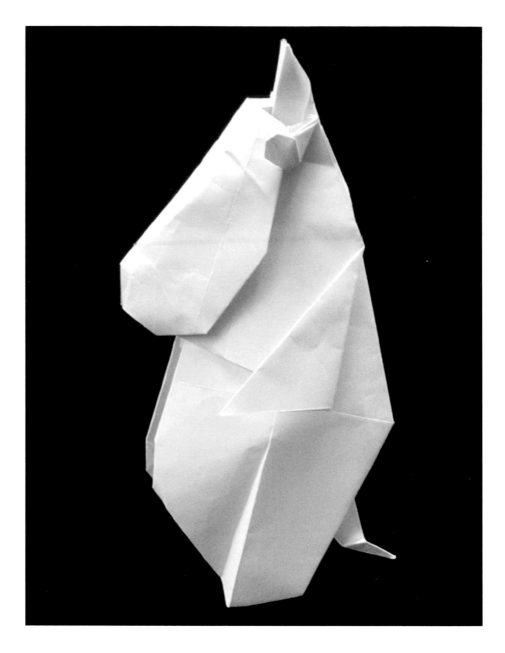

A 10-inch (25-cm) square produces a Forest Troll 5 ¹/₂ inches (14 cm) tall. The Forest Troll, inspired by figures from Scandinavian mythology, is recognizable by its pronounced snout, wide eyes, extended belly, and stubby arms and legs. Though some times mistaken for a hippotamus, it is quite unrelated.

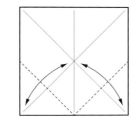

1 Use paper at least 12 inches square for your first attempt. To produce a colored Forest Troll, use paper colored on one side and begin with the white side up. Begin with diagonals and vertical centerline valley-folded. Valley-fold two bottom corners to center and unfold.

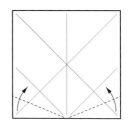

2 Valley-fold bottom edges to diagonal creases.

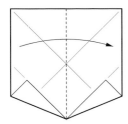

3 Valley-fold in half.

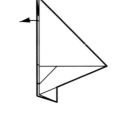

4 Valley-fold and unfold. Return to position in Step 3. This crease will be used in Step 44.

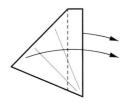

5 Fold crease XY to center-line.

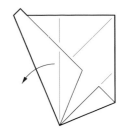

6 Unfold and repeat on right-hand side.

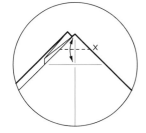

7 Valley-fold top edge to corners.

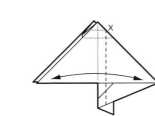

8 Reverse-fold corners along existing creases.

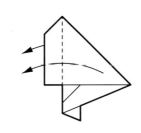

9 Valley-fold model in half.

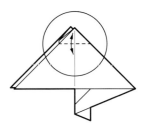

10 One at a time, swing the two top-most flaps to the right to where they fall naturally. Repeat behind.

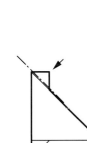

11 Reverse-fold little triangle along existing crease.

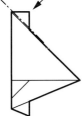

12 Pull out loose paper from little triangle. It may help to open the model slightly.

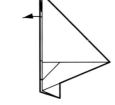

13 Swing top-most flap to the left. Repeat behind.

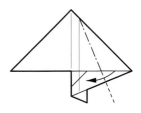

14 Swing down one flap as far as it can go and unfold. The circle shows the detail in the next step.

15 Valley-fold the tip to the crease made in the previous step. Note point X where this valley-fold meets rear edge.

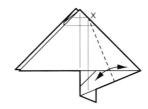

16 Valley-fold vertically at X and unfold. Repeat Step 15 and this step behind.

17 Valley-fold at X and unfold.

18 Reverse-fold through the crease just made.

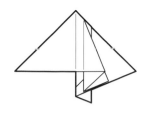 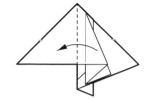

19 Repeat Steps 17 and 18 behind.

20 Swing one multi-ply flap to the left.

21 Valley-folding along the full length of the existing crease, roll the paper up and to the right until the edge just reaches crease intersection Y. Flatten with a mountain-fold. X is the point that will land on Y.

22 Swing flap down and tuck underneath along existing crease.

 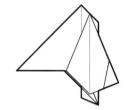 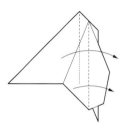 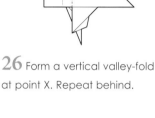

23 Form a rabbit's ear. The two long valley-folds are existing creases. The other two creases fall automatically into place.

24 Complete Steps 20 through 23 behind.

25 Swing two flaps to the right. Repeat behind.

26 Form a vertical valley-fold at point X. Repeat behind.

 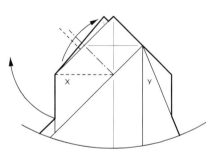 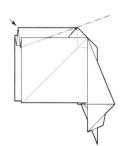

27 The circle shows the detail in the next step.

28 Pinch at X and Y to hold layers together. Pivot at X. The horizontal valley-fold at X rotates 90 degrees and becomes vertical. Carefully spread and squash the large triangular flaps on the front and back along existing creases, turning creases inside-out as necessary, to form large squares. The paper should fall into place naturally.

29 Reverse-fold the central flap as far as it will go comfortably from single point at top to two corners at left.

30 This step is an extremely complicated 3-D procedure. The entire sequence of folds must be performed before the paper lands flat. Proceed slowly and step-by-step. Push in at U and allow point X to swing up until it lands on Y. Then pinch to form a mountain-fold between X and Z. Swing XW up to align with XZ, bisecting the angle between them with a valley-fold. You

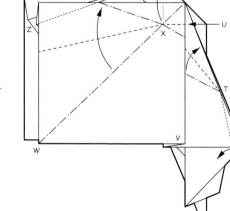

cannot press the paper flat until the paper at the right-hand side of the model falls into place. Keeping XW and XZ aligned, slowly shape the right-hand side of the paper until it lays flat. Several creases come together to form point T. Slight variations in folding may result in different locations of T. Look ahead to next diagram to see final location of all marked points. Repeat behind.

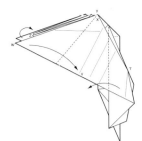

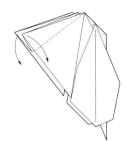

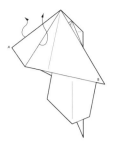

31 Swing upper left-hand flap and right-hand flap to where they fall naturally. They may overlap slightly. Repeat behind.

32 Swing front and back flaps down to where they fall naturally.

33 Pivot point B to the right, opening out loose paper. Repeat behind.

34 Gently spread open left-hand side of model and carefully pull out loose paper, turning creases inside-out as necessary.

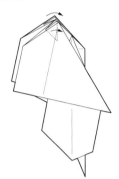

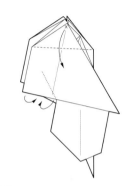

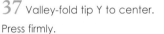
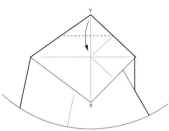

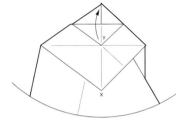

35 Reverse-fold two small triangular flaps to the right along existing creases to produce two pointy ears.

36 Lower left: Tuck in loose paper toward the center. Repeat behind. Top: Swing down corner labeled X. Flatten other flaps as symmetrically as possible where they fall naturally.

37 Valley-fold tip Y to center. Press firmly.

38 Unfold.

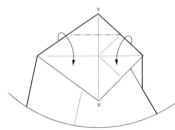

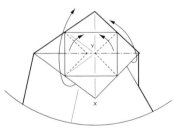

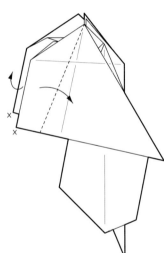

39 Spread and squash the top flap along the crease just made.

40 Close up flap X with squashed flap Y inside it. Swing the ear back up in the process, returning it to its position in Step 36.

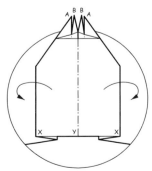

41 Valley-fold the sides of the snout toward the rear and allow the center of the snout (not visible in this diagram) to pop forward. See next step for a front view of this procedure and Step 43 for the end location of the snout. Note that points X land just forward of the belly on front and back.

42 In this front view, points X swing to the rear of the model and point Y, the center of the snout, pops forward. Flaps A will become eyes and flaps B the ears.

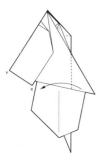

43 Valley-fold arms front and back.

44 The diagram has been rotated slightly to show the creature upright. In order to rotate the tail so it will protrude from the body, form a mountain-fold along the existing crease (formed in Step 4) that extends from inside the model to point Z at the back of the

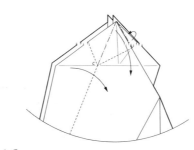

neck. Crimp the interior of the tail, forming new creases as necessary. As you rotate the tail, a valley-fold will form at Y. See Step 49 for final location of tail. The circle shows the detail in the next step.

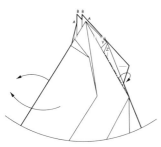

45 Reopen the snout to its position in Step 41. Tuck flap Z into the model with a mountain-fold so it is out of sight. Repeat behind.

46 In this step, the eye is swung downward with a rabbit's ear. Note that new valley-folds meet at point C. The rear of the eye flap narrows with a tiny reverse-fold.

47 Crimp tiny flap A. Narrow snout with a mountain-fold at B. Crimp flap C and swing eye on top of snout. Repeat all procedures behind. Narrow flap D as high up as crease will go without overlapping ears.

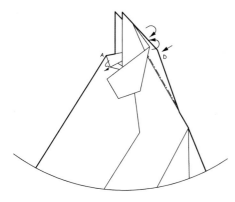

48 Tuck loose paper at A into top of snout. Repeat behind. Mountain-fold front and back of flap D and push into the model at the very center so it is out of sight.

49 Push in center of snout at top to round it. Reverse-fold tip of snout. If possible, use tweezers to lock the resulting hidden flap. Round bottom of snout with a mountain-fold and repeat behind. Round front of eye and crimp eye upward. Repeat behind. Round ears slightly. Crimp bottom of body to suggest legs and feet. The lower torso becomes 3-D. Tuck loose paper into pocket to lock torso in 3-D position. Crimp end of tail and adjust tail if necessary so model will stand.

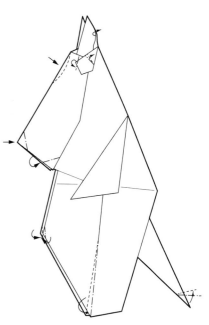

Completed Forest Troll, out for a stroll.

Spinning Top

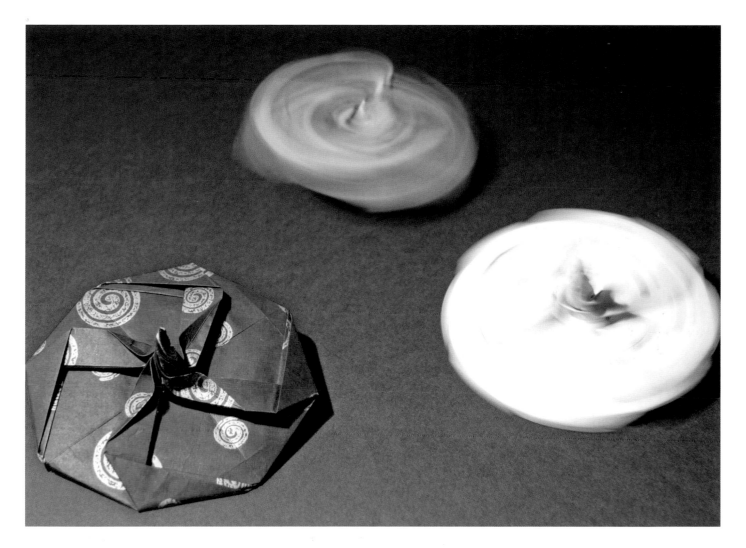

A 10-inch (25-cm) square produces a top 4 inches (10 cm) in diameter.

Readers of my book *10-Fold Origami* will note that this Top updates that book's Spinner by adding a stem.

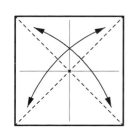

1 Begin with paper creased vertically and horizontally. Valley-fold along both diagonals and unfold.

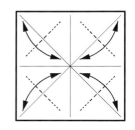

2 Lightly fold corners to center, pinch at diagonals, and unfold.

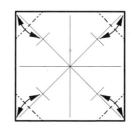

3 Lightly fold corners to pinch-marks just formed, pinch again at diagonals, and unfold.

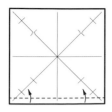

4 Valley-fold bottom edge to meet last set of pinch-marks.

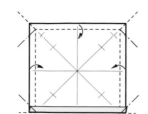

5 Valley-fold remaining edges symmetrically and swing corners outward.

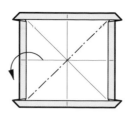

6 Valley-fold model in half along diagonal.

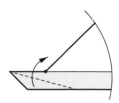

7 Diagram enlarged to show lower left-hand corner. Valley-fold firmly from tip so lower edge lands on intersection marked with a dot.

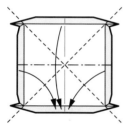

8 Unfold.

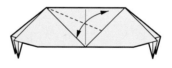

9 As suggested in this diagram, the next step will cause paper at the lower left-hand corner to be sunk upward and appear at the top.

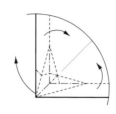

10 Open up the paper and refold along existing creases, noting which becomes a valley-fold and which a mountain-fold.

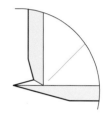

11 Step 10 completed. Repeat on three other corners.

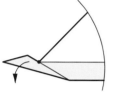

12 Collapse paper on existing creases.

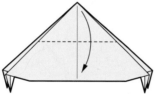

13 Valley-fold tip firmly to bottom.

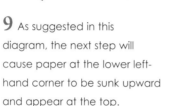

14 Valley-fold left side of little triangle to meet top horizontal edge, and unfold.

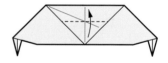

15 Valley-fold tip up firmly where angled crease crosses centerline.

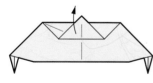

16 Open up to position in Step 11 with the colored side up.

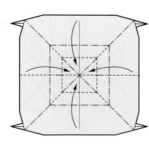

17 Mountain- and valley-fold on concentric squares formed in the earlier steps, collapsing the paper inward. Once the paper is flattened, the center will stick out above. This will be the tip that touches the table when you spin the top. Throughout the remaining steps be extremely careful not to crush this point. It may help to place the model at the edge of a table with the tip just off the edge.

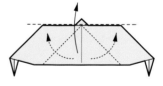

18 Lift single-ply front flap and swing it upward, spreading and flattening the inner flaps in the process. The triangular tip remains flat and unaffected by this process.

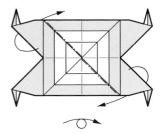

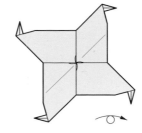

19 Grasp the upper left-hand flap and swivel it behind and to the right. Grasp the lower right-hand flap and swivel it behind and to the left. The triangular tip at the center will no longer lie flat. Turn over. The next diagram shows these moves from the back.

20 View of Step 19 from the back.

21 Steps 19 and 20 completed. The triangular tip is 3-D. Turn over.

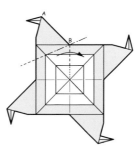

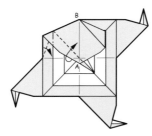

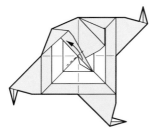

22 Swing the white paper to the right. Lift the paper in front of it slightly so that it has room to swing. When crease AB is vertical, flatten.

23 Valley-fold the thin flap directly over the main diagonal hidden beneath it. The paper at the left will rotate automatically.

24 Valley-fold the tip to the upper left to where it falls naturally.

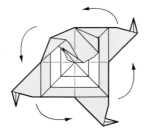

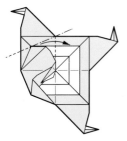

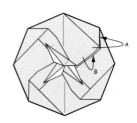

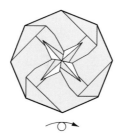

25 Rotate the model one quarter-turn counter-clockwise to align with position in Step 22.

26 Repeat Steps 22 through 25 on three other sides.

27 The fourth flap lies on top and needs to be tucked underneath. Tuck portion A into pocket behind. Then tuck portion B into pocket behind.

28 The model is now fully symmetric. Turn over to see rear.

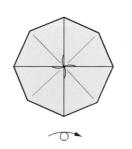

29 Rear of model. Turn over.

30 Diagram enlarged. Tuck white flaps under adjacent colored flaps.

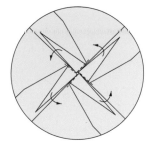

31 Lift all four flaps up from their base.

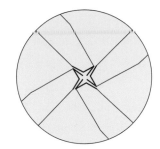

32 Flaps shown vertical.

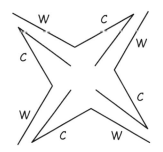

33 Diagrammatic enlargement of vertical flaps. Insert white flaps, marked W, into pockets of colored flaps, marked C.

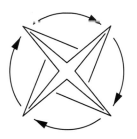

34 Step 33 completed. Pinch and rotate all four flaps between your fingers to form a single stem.

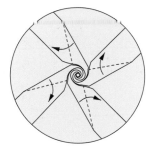

35 Step 34 completed. Valley-fold four flaps to where they fall naturally to lock top of model.

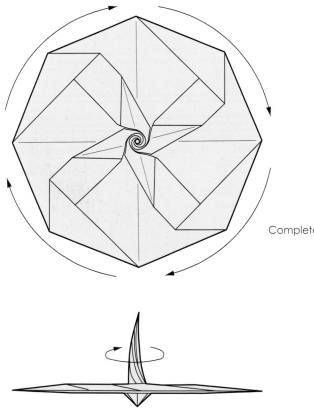

Completed Top, ready for a spin.

Cottage

A 10-inch (25-cm) square produces a cottage 2 1/2 inches (6 cm) long.

1 Begin with paper creased vertically into eighths. Valley-fold edges along closest creases.

2 Reverse-fold lower corners.

3 Pull corners apart, stretching paper along horizontal valley-fold line.

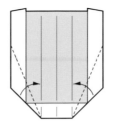

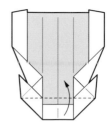

4 Fold corner portions behind with diagonal mountain-folds.

5 Valley-fold diagonal edges to vertical creases.

6 Valley-fold bottom upwards. Return paper to position in Step 4.

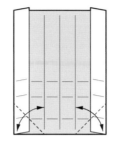

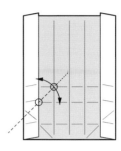

7 Valley-fold at circled intersection. Return paper to position in Step 2.

8 Valley-fold and unfold.

9 Valley-fold through circled intersections and unfold. Repeat on right side.

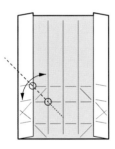

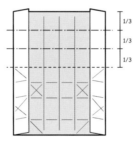

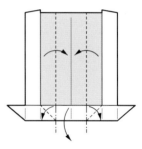

10 Valley-fold through circled intersections and unfold. Repeat on right side.

11 Valley-fold where creases formed in previous step meet edges, and unfold. Divide upper portion of paper into thirds with mountain-folds. Return paper to position in Step 7.

12 Swing bottom edge down and sides to center. Model becomes 3-D. Note position of triangular flap at lower left in this diagram.

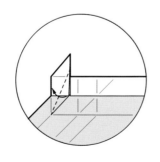

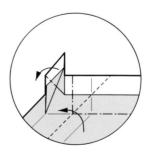

13 3-D view of corner of model with triangular flap sticking up. Valley-fold diagonal colored edge to meet vertical edge. Repeat on opposite corner.

14 Swing triangular flap down. Repeat on opposite corner. Crease as shown on both sides to make the remainder of the model 3-D. The two long side flaps will stand up and overlap each other at the center.

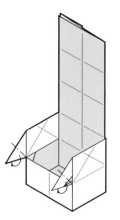

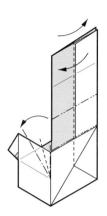

15 Standing up and partly hidden behind the center of the paper are the two long side flaps. Open up and reverse-fold the two protruding triangles along their diagonals.

16 View from the side. Pivot one long side flap to one side and one to the other so they no longer overlap in the middle. Crimp the small side flap on each side, bisecting the 45-degree angle with a valley-fold, and simultaneously swing the long flaps and center forward at a 45-degree angle. This will be the roof.

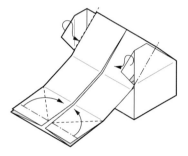

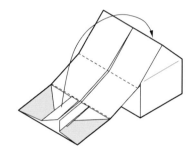

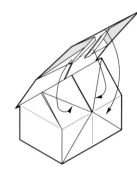

17 Diagram enlarged and seen from front. Swing side flaps inward and tuck into hidden pockets. Crimp white paper on either side of centerline at the end of the roof to make two protruding tabs.

18 Swing the roof back over the top of the cottage, bending it at the existing creases.

19 View from opposite side. Tuck protruding tabs into pockets to lock roof.

Completed Cottage.

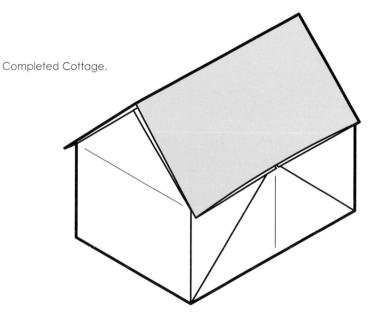

Inflatable Egg

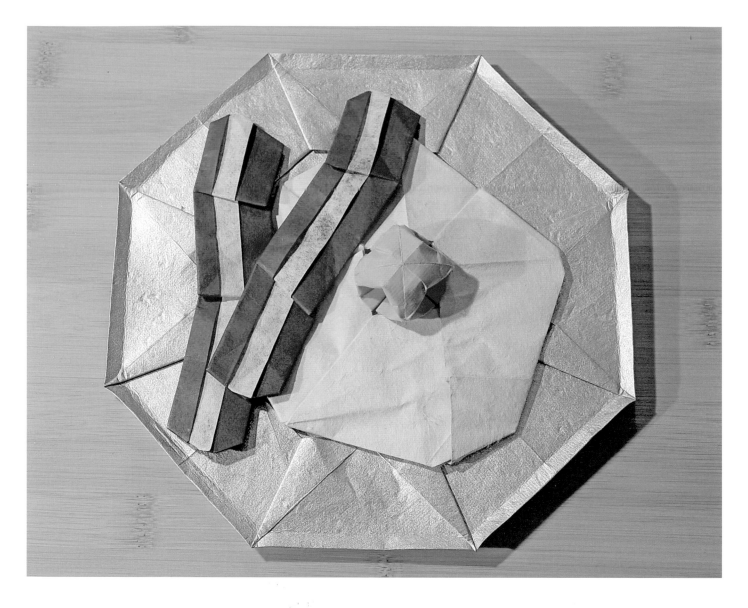

A 10-inch (25-cm) square produces an egg 5 inches (13 cm) in diameter.

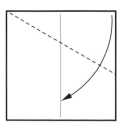

1 Begin with paper creased vertically. Lightly valley-fold so top right corner falls along centerline.

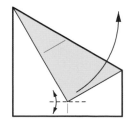

2 Lightly pinch at intersection and unfold.

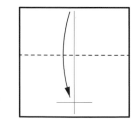

3 Firmly valley-fold upper edge to pinch-mark made in previous step.

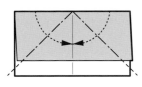

4 Reverse-fold so upper edges meet centerline.

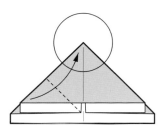

5 Valley-fold top left corner upward and crease lightly. Circled area shows enlargement in next diagram.

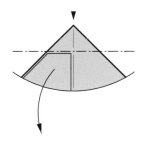

6 Mark top edge of flap, then open sink along that line. Swing left-hand flap back down.

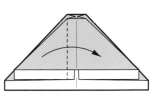

7 Vertically valley-fold at edge of sink-fold.

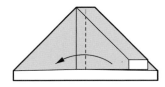

8 Vertical valley-fold falls along centerline.

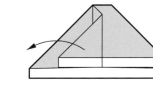

9 Unfold.

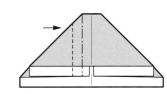

10 Inside reverse-fold along creases just made.

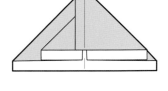

11 Step 10 completed. Repeat Steps 7 through 10 on three other corners.

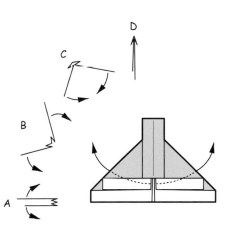

12 Swivel hidden vertical edges upward and outward. Cross-sections A through D show the position of the multiple paper thicknesses as the paper follows its arc.

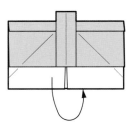

13 Step 12 completed. Swing the white portion of the paper behind and up.

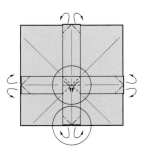

14 Circled area at bottom shows typical edge condition enlarged in Steps 15 and 16. Circled area at center is enlarged in Steps 17 and 18.

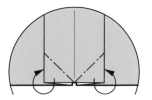

15 Mountain-fold little triangles behind.

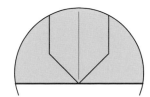

16 Step 15 completed. Repeat on three other sides.

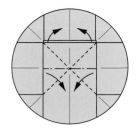

17 Swing front of flap downward and spread sides symmetrically.

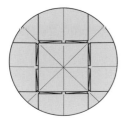 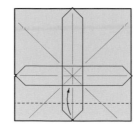 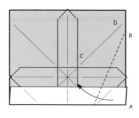 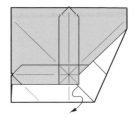

18 Step 17 completed. Center is symmetric.

19 Valley-fold bottom edge up to meet horizontal edge.

20 Valley-fold so edge AB is parallel to crease CD and tucks as far as possible under the central square. There is only one location for this fold.

21 Pull out loose paper.

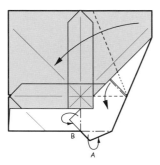 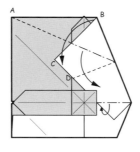 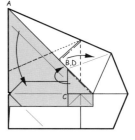

22 Tuck loose paper A underneath and B into pocket beneath. Valley-fold triangle at right-hand side and swivel the upper right-hand corner down and to the left so that it tucks as far as possible under the central square. There is only one location for this fold.

23 Lift the triangle folded down in the previous step and tuck it underneath. Valley-fold from A to right-hand edge so that AB falls directly on CD. Swivel paper so that B lands on D and the triangle that ends at C turns upside down.

24 Note positions of points A, B, C, and D. Lift the shaded triangle that ends at C and tuck it underneath. Tuck white paper that overlaps the central square underneath the adjacent corner of the square. Valley-fold white triangle to the right and swivel down corner A so that it tucks as far as possible under the central square.

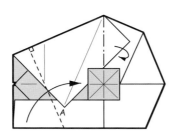 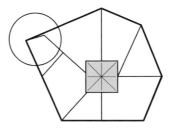

25 Lift the triangle folded in the previous step and tuck it underneath. Valley-fold the lower left-hand corner perpendicularly to the upper left-hand edge so that the corner tucks as far as possible under the central square.

26 Circle shows area of enlargement in next diagram.

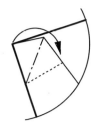

27 Reverse-fold corner to edge.

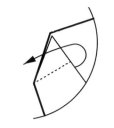

28 Open out to position in Step 25.

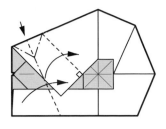

29 Push in at short arrow, swing paper to right, and refold along existing creases.

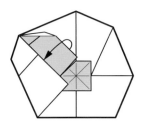

30 Swing colored paper to left and tuck under white paper to lock.

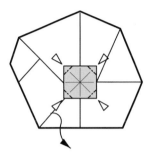

31 Pull out loose paper at lower left. Open-sink four corners to create an octagon.

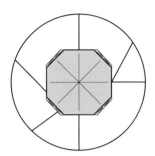

32 Enlargement of center. Open-sinks completed.

33 Tuck loose paper underneath to lock final flap.

34 Open-sink to round two corners. First crease with valley- or mountain-folds, then open out paper, sink, and close again. Turn over.

35 Blow into hole at center and ease out yolk on opposite side.

Completed Inflatable Egg, shown with the rest of the Breakfast Special from my book *10-Fold Origami*. The Plate was designed by Gabriel Perko-Engel.

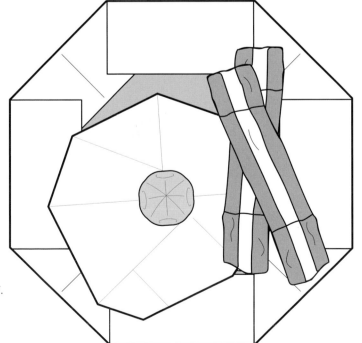

Sea Serpent

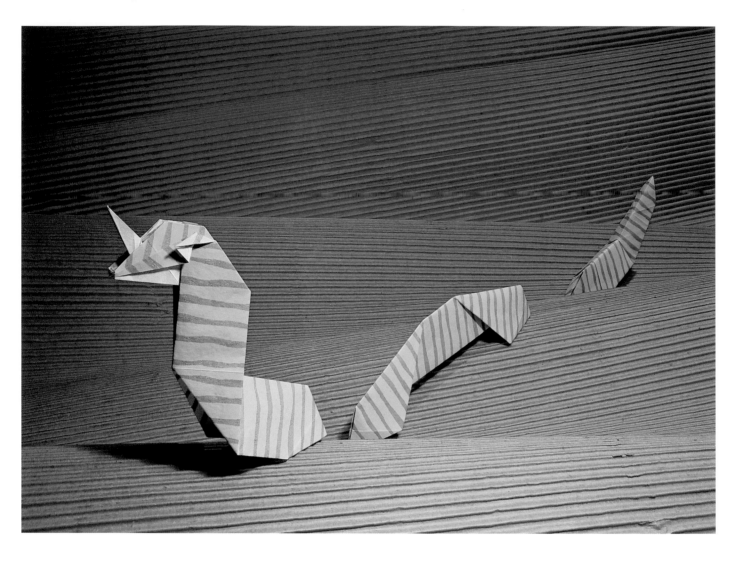

Head

Three unattached 10-inch (25-cm) squares produce a serpent approximately 18 inches (46 cm) from head to tail.

1 Begin with paper creased along both diagonals. Fold top and bottom tips, not quite to the center.

2 Unfold.

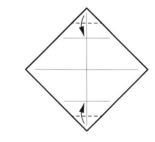

3 Valley-fold tips to creases formed in Step 1.

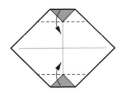

4 Valley-fold at tips.

5 Valley-fold at edges.

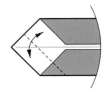

6 Diagram enlarged. Crease edge to edge and unfold.

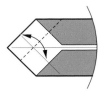

7 Crease edge to edge and unfold.

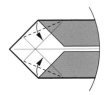

8 Valley-fold so edges meet creases just formed.

9 Valley-fold vertically and unfold.

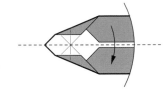

10 Valley-fold in half.

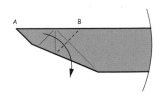

11 Diagram enlarged. Valley-fold so that edge AB becomes vertical.

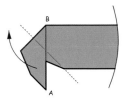

12 Step 11 completed. Note alignment of diagonal creases. Unfold.

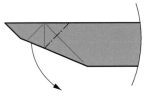

13 Reverse-fold along crease formed in Step 11.

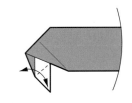

14 Valley-fold from intersection to intersection and unfold.

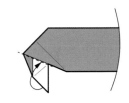

15 Reverse-fold full thickness of flap along edge and tuck inside.

16 Form hidden valley-fold along crease made in Step 14 to lock model.

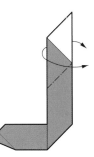

17 Outside reverse-fold so right-hand side of model becomes vertical.

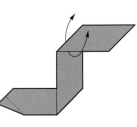

18 Outside reverse-fold so top of model becomes horizontal.

19 Pull out loose paper.

20 Diagram enlarged. Reverse-fold along edge and unfold.

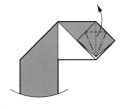

21 Valley-fold is vertical. Spread and squash flap to form a square.

22 Not shown: Valley-fold edges of square to centerline and unfold. Then swing tip up and allow edges of paper to meet at center.

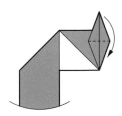

23 Swing tip back down.

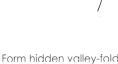

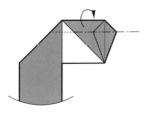

24 Mountain-fold top behind along existing horizontal crease.

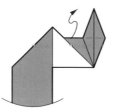

25 Pull out paper and unfold to position in Step 21.

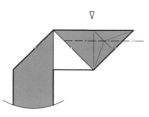

26 Spread model slightly and open-sink along existing horizontal crease.

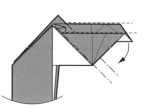

27 Open-sink completed. Reverse-fold along existing creases and swing tip down.

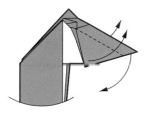

28 Step 27 in progress.

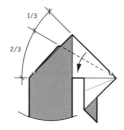

29 The model is now flat. Valley-fold front of head, dividing angle into thirds. Repeat behind.

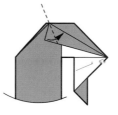

30 Valley-fold edge to edge to form eye.

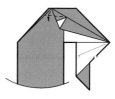

31 Valley-fold edge to edge.

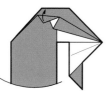

32 Unfold previous step.

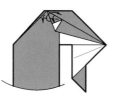

33 Reform creases made in Steps 30 and 31, stretching paper to form top of eye.

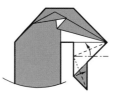

34 Follow existing creases to narrow point at bottom.

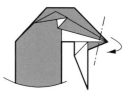

35 Mountain-fold front flap at a slight angle. Do not repeat behind.

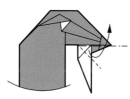

36 Reverse-fold symmetrically along existing edge to form horn.

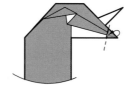

37 Valley-fold rear flap and tuck into pocket made by front flap to lock head.

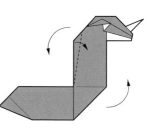

38 Valley-fold back of neck. Repeat behind. Rotate model slightly so bottom rear edge is horizontal. Note that model will not stand on its own.

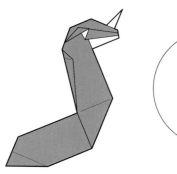

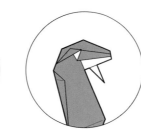

39 Completed head. Experiment with alternative heads, producing a mouth or beard.

Body

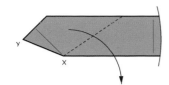

40 Begin with Step 16 of head completed. Repeat Steps 6 through 16 on right-hand side so model is symmetric. Only the left-hand side of the body is shown. Valley-fold so that edge XY becomes vertical.

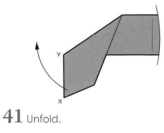

41 Unfold.

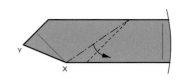

42 Form a mountain-fold on the front along the crease formed in Step 40. Crimp paper, forming a new valley-fold, so that edge XY becomes horizontal.

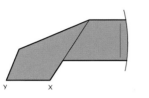

43 Step 42 completed. Repeat Steps 40 through 42 on the right-hand side.

44 Body completed.

Tail

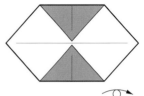

45 Begin with Step 2 of the head. Turn over.

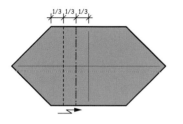

46 Crimp left-hand side.

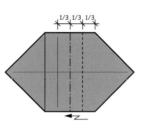

47 Crimp right-hand side.

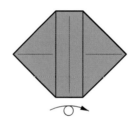

48 Crimps completed. Turn over.

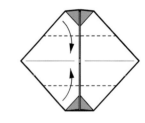

49 Valley-fold edges to just shy of centerline.

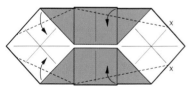

50 Diagram enlarged. Left side: Fold Steps 6 through 8 of the head. Right side: Valley-fold from intersections at top and bottom to intersections marked X.

51 Left side: Complete Steps 9 through 16 of the head.

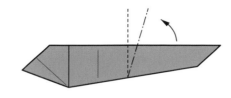

52 Crimp tail symmetrically. The valley-fold is perpendicular to the top edge. Rotate model slightly so bottom left edge is horizontal. Note that model will not stand on its own.

53 Completed tail.

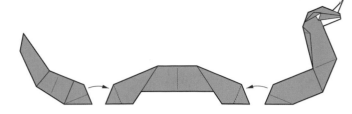

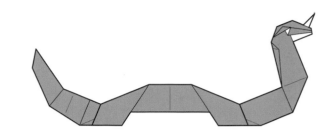

54 The three pieces of the Sea Serpent can be either attached or detached. To attach them, tuck the head and tail into pockets at the front and back of the body. The model will stand.

55 Completed Sea Serpent with the pieces attached.

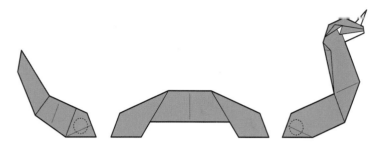

56 For the detached version, open the head to Step 10 and the tail to Step 51 and insert two appropriately-sized coins into the pockets as shown. Then refold. Each piece will now stand on its own.

57 Locations of coins shown in the detached version. Add more body pieces if desired.

Completed Sea Serpent.

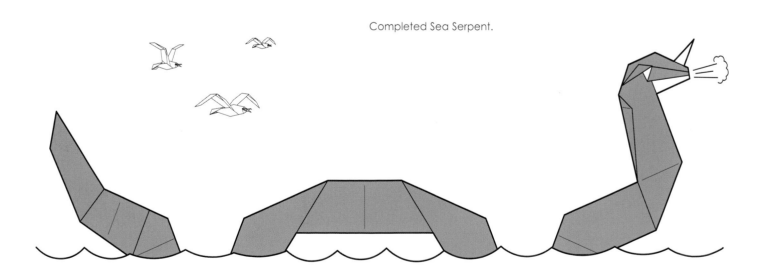

Acknowledgments

Producing a high-quality, fully illustrated craft book that ventures into arcane areas of Asian philosophy and aesthetics is challenging enough; doing so in the current economic climate is little short of a miracle. My thanks go to my editor, William Notte, for steering this extremely complex project through the vicissitudes of the publishing process from beginning to end, and to the book's designer, Kathryn Sky-Peck, for giving coherence and beauty to its disparate and wide-ranging material. Anthoney Chua and designer Kathy Wee-Maran in Tuttle's Singapore office provided invaluable support. My thanks go also to Nondita Correa-Mehrotra for writing the insightful Foreword and to Sunny Grewal for his excellent photographs of the origami models.

The DVD of origami videos that accompanies this book could not have been accomplished without the abundant creativity, technical wizardry, patience, and humor of Gabriel Perko-Engel. He was truly the project's mover and shaker (though fortunately not with video camera in hand). Filmmaker, photographer, and occasional exhibit curator Kate May produced the fine video portrait. The directors of the East Bay Media Center in Berkeley, CA, Mel Vapour and Paul Kealoha Blake, and their associate, Juan Vargas, provided timely technical assistance and unfailing encouragement.

Over the past decade, I have been given the opportunity to exhibit my origami designs and sculptures in a variety of venues. Origami is not standard gallery- and museum-fare; the curators and sponsors of those shows invested much time and creative energy and took some risks along the way. My thanks go to Molly Hutton at the Gettysburg College Art Gallery and Kim Kupperman and Dusty Beall Smith at Gettysburg College; Reneé Baldocchi at the de Young Museum; Pamela Livingston and Phyllis Thelen at Art Works Downtown; Allison Wyckoff and Deborah Clearwaters at the Asian Art Museum; Snowy Tung and Sunny Green at the Oakland Museum of California; Marshall Bern and Lisa Fahey at the Palo Alto Research Center; Kate May and Janet Koike at Rhythmix Cultural Works; and Terry Donohue and Elia Haworth at the Bolinas Museum. I am grateful to four fellow origami creators, Robert Lang, Linda Mihara, Bernie Peyton, and Jeremy Shafer, who provided the impetus for several of the above exhibits and jointly designed, shaped, and installed artwork in those venues.

Mao Tseng, who drew the diagrams for this book and assisted with photographing the models, has been my artistic partner in designing and fabricating more than a few far-flung and far-out exhibits and architectural projects. Equally handy with a computer mouse and a blowtorch, he has been a superb collaborator and a great friend.

Four of my guiding spirits have passed away in recent years. In very different ways, they set the highest possible standards of curiosity, creativity, and compassion. I am grateful to have had the guidance, over three decades and more, of Akira Yoshizawa, Arthur Loeb, Martin Gardner, and Walter Gruen.

My parents, Marjorie and Stephen, and my brother, John, have encouraged my passion for origami from the beginning. My wife, Cheryl, and my daughter, Hannah, and son, Gabriel, have inspired the designs within these pages and supported me with love, patience, and humor beyond measure. I dedicate this book to them all.

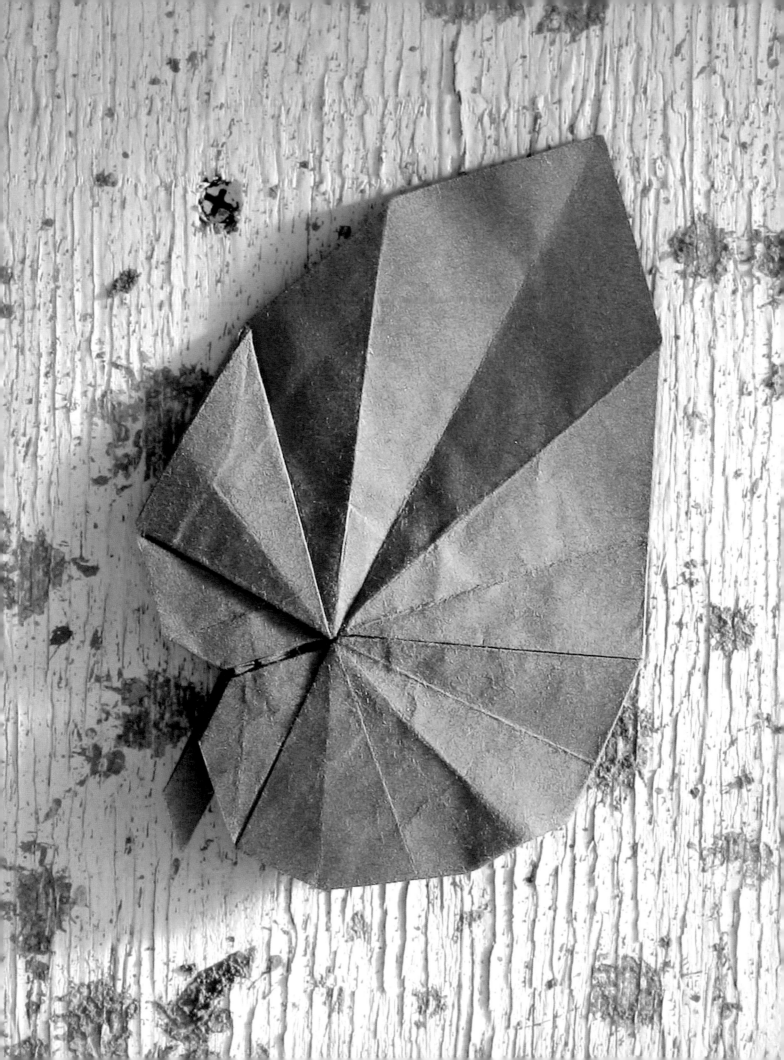